IMAGES
of America

AROUND ALDINE

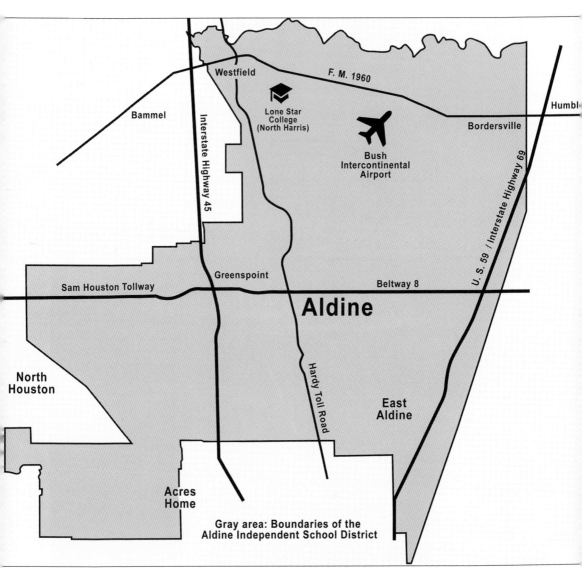

ALDINE AND THE ALDINE INDEPENDENT SCHOOL DISTRICT TODAY. The unincorporated town of Aldine developed near present-day Hardy Toll Road and Aldine-Bender Road, south of Beltway 8. The Aldine Independent School District (AISD) comprises 111 square miles, with Houston ISD to the east and the south, Klein ISD and Cy-Fair ISD to the west, Spring ISD and Conroe ISD to the north, and Humble ISD to the northeast. (Courtesy of Dr. Robert Meaux.)

ON THE COVER: J.C. CARPENTER FIG CO. John Carpenter—the "Father of the Skinless Preserved Fig Industry"—opened his first fig factory in Aldine in 1907. His J.C. Carpenter Fig Co. was one of the largest employers in Aldine in the 1910s and shipped figs across the United States. (Courtesy of Houston Metropolitan Research Center, Frank Schlueter/Bank of the Southwest Collection.)

IMAGES
of America

AROUND ALDINE

Mark W. McKee and Dr. Robert Meaux

ARCADIA
PUBLISHING

Published by Arcadia Publishing
Charleston, South Carolina

Printed in the United States of America

Library of Congress Control Number: 2022944005

For all general information, please contact Arcadia Publishing:
Telephone 843-853-2070
Fax 843-853-0044
E-mail sales@arcadiapublishing.com
For customer service and orders:
Toll-Free 1-888-313-2665

Visit us on the Internet at www.arcadiapublishing.com

Dedicated to Edgar Reeves, Sharon Richter, Virginia Perryman, and Robert Miller for encouraging my love of history, geography, and writing.

—Mark W. McKee

CONTENTS

Acknowledgments

We would like to thank the following people for their assistance: Edgar Reeves; Elizabeth Battle; Gerald Wesbrook; Katie Meaux; Aldine ISD employees Gwen Givens, Michael Keeney, Chris Labod, Patrick Mouton (executive director of facilities, planning, and construction), and Abel Garza (assistant superintendent of community and governmental relations); Geoff Scripture, Michael Bludworth, and the 1940 Air Terminal Museum; Laney McAdow Chavez and Annie Golden at the Harris County Archives; Maritza Sepulveda, Maria Avila, and the good people at the East Aldine Management District; Anne L. Cook at the Texas Department of Transportation Communications Division; Bill Van Rysdam at Lone Star College; Sylvia Podwika and the staff of the Woodson Research Center at the Fondren Library, Rice University; and especially the staff at the Houston Metropolitan Research Center.

INTRODUCTION

Before the 19th century, the land between Cypress Creek and Halls Bayou sat empty. Only bands of Akokisa Native Americans occasionally passed through it. No one has found any settlements to date. Archeologists have uncovered evidence of a bison hunt in Keith-Wiess Park. The remains date from 800 AD to 1750 AD, suggesting tribes used the future park as hunting grounds.

In April 1836, Texas gained independence from Mexico. The new nation granted war veterans one third of a league of land (1,476 acres) for their service. Grant holders did not have to live on their land. Several veterans, including some with grants around what would later become Aldine, sold or deeded their land to others. As such, Aldine remained vacant for years. German immigrant and veteran Johann Frederick Schlobohm and his wife, Caroline, built a homestead along Greens Bayou in 1856. They were among Aldine's first documented settlers. Their farm sat off today's Lauder Road, west of Brookside Cemetery.

In 1871, the Houston & Great Northern Railroad (H&GN) constructed a 55-mile track from Houston to New Waverly, a town in Walker County south of Huntsville. Not long after, the H&GN set up a train stop along the rail line just south of Greens Bayou. Today, this spot lies buried under the Hardy Toll Road at Aldine-Bender Road. H&GN dubbed the stop Prairie (or Prairie Switch) after the surrounding flat, treeless land. H&GN merged with the International Railroad in 1873, forming the International & Great Northern Railroad (I&GN). In November 1883, I&GN changed the name of Prairie to Aldine. The railroad gave no reason for the decision—it was just one of many similar name changes announced that day.

Local legend states the name originated from how a conductor would yell "All dine" as the train approached the stop, indicating passengers could disembark to get something to eat. Eventually, "all dine" morphed to Aldine. This story lacks credibility, though. No restaurant or hotel dining room existed in Aldine in 1883. One would not open until 1902, nearly 20 years later. Moreover, I&GN offered dining car services between Houston and Willis beginning in 1878. Passengers never had to leave the train to dine. So what prompted I&GN to change Prairie to Aldine? Perhaps it refers instead to the dining car. No one knows.

Thanks to railroads like I&GN, people could travel quickly within the United States. Many looked for new, more promising places to settle. Texas proved a popular destination. Ferris W. Colby was a well-traveled Ohioan who had already made many real estate deals in Texas. He likely saw I&GN's newspaper advertisements about moving to the Lone Star State. Colby figured he could profit from selling Aldine land to northerners wanting to live in a warmer climate. In February 1889, he acquired acreage around the Aldine train stop and opened a land agency.

Norwegian and Swedish families were among the first settlers to arrive. Names of these early families still adorn area street signs and schools—Oleson, Lillja, Reeves, Henry, Sellers, Hambrick, Luthe, Spence, Patterson, and others. Colby envisioned a thriving community centered on Hardy Road at Aldine Road (now Aldine-Bender Road). Between 1900 and 1907, he planned streets and lots for homes, stores, churches, schools, a train depot, and even a hotel/boardinghouse.

Agriculture dominated the early Aldine economy. Dairies were an important industry, as was truck farming (raising garden produce for sale). Citrus orchards sprang up in the early 1900s, but a freeze later wiped out most of the crop. Some citrus growers turned to figs and enjoyed immediate success. One Aldine farmer, John C. Carpenter, won a silver medal for preserved figs at the 1904 St. Louis World's Fair. The award inspired Carpenter to start an Aldine fig cannery in 1906. The factory prospered in the 1910s, but sugar rationing during World War I, changing consumer tastes, and blight from frequent rains doomed the industry by the 1920s.

Education around Aldine began in 1876. Two small schools arose near what is now George Bush Intercontinental Airport. Westfield stood on the north side and Higgs on the east. Each community operated one-room schoolhouses for first through seventh grade students. They joined forces in 1884 to form Harris County Common School District 29 (CSD 29). The one-room Aldine primary school followed in 1898. A larger, two-room structure replaced it in 1910. CSD 29 also operated two other primary schools: Hartwell, near the modern Lone Star College–North Harris, and Brubaker at Airline Drive and Blue Bell Road.

Segregation was the law of the land, so black children attended separate schools near Westfield, Higgs, and Humble. CSD 28 opened the Humble school in 1909 but contracted with neighboring CSD 29 in 1932 to provide teachers.

Before the mid-1910s, society viewed a high school education as unnecessary and irrelevant for rural students aspiring to be farmers. Texas students were not required to attend school past the seventh grade at the time. However, as the world grew more complex, the attitude toward rural education quickly changed. Around 1912, CSD 29 started a high school for grades eight and nine at Hartwell. The high school lasted until the 1920s when the district discontinued it, likely due to a lack of funds. CSD 29 began busing white students wanting a high school education to Houston or Humble.

The Aldine, Brubaker, Hartwell, and Higgs white schoolhouses grew overcrowded by 1932. That summer, CSD 29 unveiled plans for a centralized brick school near Aldine, the geographic center of the district. The two-story, redbrick structure would house CSD 29's white primary students in one 12-room facility. The building also had space for high school classes, the first time the district could offer such a program since the Hartwell high school had closed.

Construction began after Labor Day in 1932. The district hired a superintendent and additional teachers. It temporarily held high school classes at Memorial Baptist Church on Airline Drive at Gulf Bank Road. The new school building opened in February 1933. The Parent-Teacher Association later recommended naming it Marrs School to honor S.M.N. Marrs, state superintendent of schools until his death in April 1932. Marrs sought better funding for high schools and improved rural education during his term. These were issues important to CSD 29.

By 1935, area residents wanted greater control over their local schools. In May 1935, voters created the Aldine Independent School District (AISD) and elected seven trustees. AISD annexed parts of two neighboring school districts to the west and southwest in 1935 and 1937, expanding from 97 square miles to 114. The 1937 partial annexation of CSD 26 (White Oak) brought Acres Homes, a predominately black neighborhood, into AISD. In 1941, the district started a high school for blacks within the existing community. This high school would eventually become Carver High and move to a separate on-site facility later that decade and a dedicated new campus nearby in 1954.

As the city of Houston expanded northward, AISD experienced a population surge in its southernmost sections. This growth meant the district had to open new schools outside its centralized complex. Orange Grove Elementary was the first of these, opening in 1947 on East Mount Houston Road, just west of US 59. Three other elementary schools followed in rapidly growing southern AISD by 1954.

Meanwhile, the Marrs School's high school unit moved twice due to a growing enrollment—once to a combination junior/senior high in 1936 named Marrs High and to its own building in 1948, christened Aldine High School. The former Marrs High became Aldine Junior High School. A Thanksgiving Eve 1954 fire destroyed Aldine High School six years after it opened. Officials rushed forward existing plans for a larger school five miles away on Airline Drive. The modern

Aldine High School on Airline Drive at West Road opened in September 1956 and remains in operation today.

Early AISD consisted of rural farms and homesteads. There were few high-value industries in the district. Homeowners bore the bulk of the school tax burden, which AISD supplemented with state and federal aid. Several homeowners, frustrated with high taxes and what they considered lavish spending by the district, formed a taxpayers association. This association won several school board seats during the mid- and late 1950s. The group cut taxes and adopted a bare-bones budget. The association's tight-fisted methods eventually pushed the school district to the edge of insolvency. The final straw came when association-backed school board trustees ceded the AISD-zoned portion of Oak Forest and Langwood to the Houston ISD. The neighborhoods represented only two percent of AISD's land area but paid one-fifth of the district's taxes.

Losing Oak Forest's and Langwood's tax payments proved nearly fatal in the spring of 1959. AISD had to shut down its schools twice because it lacked funds to pay its teachers and staff. The state and the district ultimately found a novel way to raise money to reopen schools, but only after several weeks of unplanned vacation. The episode taught taxpayers, administrators, and school board members the value of sound fiscal policy. It is a lesson the district has never forgotten. AISD today consistently wins awards for its financial management practices—a stark contrast to the turbulent late 1950s.

AISD desegregated in 1954 following the *Brown v. Board of Education* ruling. However, black residents sued in 1965, and the federal government filed suit in 1977, contending the district was not doing enough to ensure integration. Court-ordered busing went into effect in 1977 and lasted for 25 years. It ended in 2002 after AISD convinced the federal court that changing demographics had rendered the busing order moot.

The district has grown from nearly 600 students in 1935 to more than 67,000 in 2021. Today, AISD boasts 83 campuses spread out over 111 square miles in north-central Harris County. The expanding number of schools reflects changing public attitudes toward education. AISD once ran a traditional three-tier system of elementary schools, junior highs, and senior highs. Now the district operates these types of campuses and several new types of institutions. These include early childhood and pre-K centers, magnet schools, ninth-grade schools, alternative schools, and vocational and early college high schools.

Aldine remained semirural until the early 1960s, when Houston began building an international jet airport in AISD's northeastern corner. Houston Intercontinental Airport (now George Bush Intercontinental) debuted in June 1969. Its development attracted thousands of new residents and businesses, transforming the area from a sleepy backwater to a suburban juggernaut.

Armour and Co. blazed a trail to Aldine in 1961, building a modern meat processing and packing plant off Rankin Road. In the early 1970s, energy companies migrated to the area. They liked the cheap land close to the new airport, which let their employees quickly travel to energy-producing regions across Texas, the United States, and the world. Field service organizations Oil Tool Co. and Drilco were the first to arrive. Others quickly followed, including industry titans such as Baker Hughes, Hydril, NL, and Varco. Producers such as Exxon and Amoco occupied multiple floors of office towers that sprung up seemingly overnight along the North Belt in the late 1970s and early 1980s. These companies and many more brought high-paying jobs to an area once dominated by dairying and farming.

Vast tracts of open prairie suddenly turned into housing and apartment developments. Hidden Valley introduced ranch-style tract housing to Aldine. Hidden Valley's big selling points were affordable, mid-priced homes and no city taxes, as the neighborhood was then in unincorporated Harris County. The developer eventually built more than 1,200 homes in Hidden Valley between 1956 and 1972. Other large tract housing developments soon competed with Hidden Valley for buyers, including Oakwilde, High Meadows, Green Ridge North, and Imperial Valley.

Meanwhile, countless strip shopping centers and a large regional mall satisfied newcomers' shopping needs. National retail chains, including Globe, Sears, Woolco, Grant's, and Kroger, opened around Aldine. Regional and local retailers such as Foley's, Weiner's, Leonard's, and

Weingarten's joined them, wanting to cash in on the area's growing population and prosperity. Sleek new multilane freeways like the North and Eastex let residents and workers travel quickly and effortlessly to every part of the county and beyond. Aldine grew so fast that the *Houston Business Journal* predicted in 1982 it might soon become a northside downtown. Unfortunately, the heyday did not last. Twin oil busts in the 1980s shook the local economy. Foreclosures left neighborhoods with scores of empty homes. An apartment glut drove down occupancy and led to neglected properties. A fatal shooting outside Greenspoint Mall forever stigmatized the area as a crime-ridden "Gunspoint."

Houston annexed large swaths of the Aldine area, prompting an exodus of white residents still wanting a middle-class suburban life and low taxes to move farther north to Spring, Klein, and The Woodlands. Major employers followed, taking jobs with them.

In their place came lower-income immigrants from Mexico and Central America searching for a better life outside the increasingly expensive central city. The new arrivals brought many of their customs from their homelands to Aldine. Among them were the open-air flea markets (*pulgas*) along Airline Drive. Pulgas became popular places to shop and socialize with people from similar cultural backgrounds.

New names catering to Hispanic customers replaced familiar national and statewide retail and restaurant chains. Fiesta, for example, took over from Safeway and Minimax. Champs Diner became Mambo Seafood. Weiner's is now Fallas Paredes.

Even churches have had to adapt, change, or move. Memorial Baptist Church, a local institution that opened in 1931, followed its members to Spring in 2003. Berean Baptist, meanwhile, remains in its longtime location on the North Freeway, but is now Iglesia Bautista Berean, with services in English and Spanish to serve the local community's spiritual needs.

Aldine has suffered a host of crime and gang problems since the early 2000s. The Haverstock Hills apartment complex on Aldine-Bender Road became notorious for gunfire and gang violence. In 2009 alone, law enforcement authorities logged more than 3,000 service calls from Haverstock Hills. The City of Houston, meanwhile, ordered the demolition of several problematic apartment complexes. One demolished development along Airline Drive became the site of an AISD elementary school, offering hope that other similar actions could follow.

As Aldine transformed from rural farmland to an urban landscape, buildings and concrete now cover its once open, vacant land. Several unforeseen and unintended consequences stem from this situation, increased flooding chief among them. The area's two main streams—Greens and Halls Bayous—can no longer carry off excessive rainfalls. Massive floods hit Aldine in 2001, 2016, and 2017. Even small downpours can cause flooding issues. Harris County has poured millions of dollars into flood control projects since the beginning of the 21st century, hoping to stem the deluge.

Nearly a quarter into the 21st century, Aldine struggles with changing socioeconomic conditions, crime, flooding, negative outside perceptions, an empty mall, and traffic snarls. However, local management districts in East Aldine, Airline, and Greenspoint have restored a sense of civic pride and show renewed promise for the future.

One

EARLY ALDINE

Aldine looked quite different 100 years ago. Freeways, malls, supermarkets, and fast-food restaurants did not exist. Instead, dairies and produce farms dotted the landscape. Daily life then also bore little resemblance to modern times.

Days began before dawn. Students finished chores before going to school, rain or shine. Men toiled in the fields from sunup to sundown. Boys helped during the summer. Women worked 13-hour days around the house, six days a week, assisted by daughters after school.

Farmers raised crops for cash and kept gardens for their families. Mothers cooked meals from scratch on wood-burning stoves. Aldine did not get electricity until 1936. Family, church, school, and clubs occupied limited leisure time. Ice cream socials, box suppers, and dances were popular, as were parlor games, fishing, and hunting. School activities included football, basketball, baseball, and track.

KPRC debuted as Houston's first commercial radio station in 1925; KTRH and KXYZ followed soon after. Families gathered around the radio every night. They learned the latest news, heard musical performances, and enjoyed weekly serials. KLEE-TV (now KPRC) signed on as Houston's first television station in 1949. KGUL (now KHOU) and KTRK came along in 1953 and 1954. Early viewers liked westerns, comedies, and variety shows.

People seldom dined out; they considered it an expensive luxury. Aldiners visited Windswept Inn on Airline Drive and Log Cabin Inn on Lee Road at US 59 when wanting a meal outside the home. Both served fried chicken dinners family-style.

H&H Guest Ranch on Greens Road opened in 1947. Visitors enjoyed hayrides, picnics, swimming, horseback riding, and golf. H&H even offered plane rides and skydiving. Circle 8 Rodeo on Aldine Mail Route held riding and roping competitions starting in 1951. Primrose Downs hosted quarter horse racing after 1952 on Lee Road at US 59.

North Houston Speedway, also off Lee Road, sponsored stock car races in the mid-1950s. The Humble Drive-In was Aldine's first local movie venue. It opened around 1957 on US 59, near Carpenter Road.

Times were different but seldom dull.

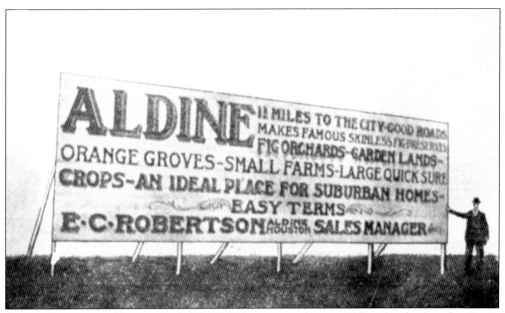

ALDINE BILLBOARD. Eugene Cook "E.C." Robertson took over Aldine land sales after Ferris Colby moved on to other pursuits. By the 1910s, Robertson heavily marketed Aldine's potential through advertisements, brochures, and billboards like this one. He even once held a Farming with Dynamite demonstration to draw publicity. (Courtesy of Aldine ISD Mendel Heritage Museum.)

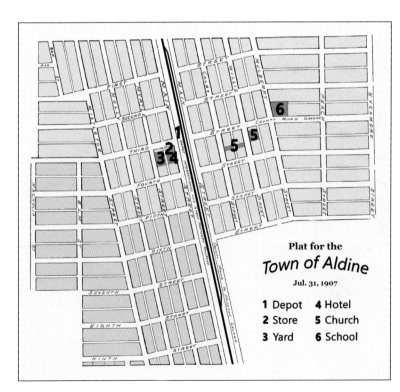

ALDINE TOWN MAP. Ferris Colby filed several plats for a town of Aldine between 1888 and 1907. Colby envisioned Aldine as a bustling business hub along the railroad 11 miles north of Houston. While called a town in plats, Aldine never incorporated and had no mayor or city council. (Courtesy of Mark McKee.)

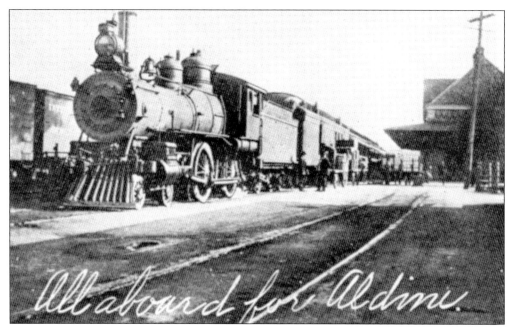

HOUSTON TRAIN TO ALDINE. The International & Great Northern Railroad spurred Aldine's early economic development. By the 1900s, three daily trains like this one—stopped at an unidentified depot that was not Aldine—passed through town on their way to Houston or the railroad's end in Palestine. (Courtesy of Aldine ISD Mendel Heritage Museum.)

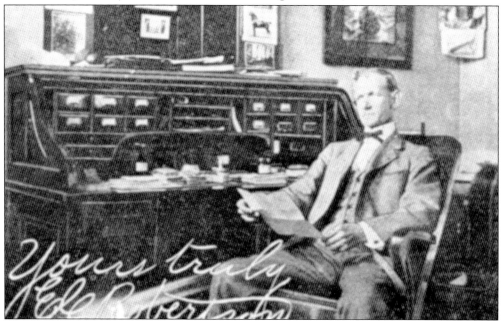

EUGENE ROBERTSON. Taking over from Ferris Colby around 1906, Eugene Robertson handled Aldine land sales from the Kiam Building in downtown Houston. Robertson marketed Aldine across Texas and the United States. He focused on the colder regions of the country. Robertson's brochures, advertisements, letters, publicity articles, and billboards described Aldine's farming potential and warm climate in glowing terms. (Courtesy of Aldine ISD Mendel Heritage Museum.)

ALDINE POST OFFICE. The Aldine Post Office opened in 1902, replacing an earlier structure destroyed in the infamous 1900 hurricane. The post office closed in 1935, and mail was delivered from Houston thereafter. This picture was taken in 1940 after the building was repurposed. (Courtesy of Aldine ISD Mendel Heritage Museum.)

EARLY ALDINE HOME. Pictured is a typical early-20th-century Aldine dwelling on Hardy Road. Homes at this time were often crowded, with several generations living under one roof. Families had more children at that time than their modern counterparts. Early homes also lacked electricity, air-conditioning, heating, refrigeration, and other conveniences frequently taken for granted today. (Courtesy of Aldine ISD Mendel Heritage Museum.)

ADVERTISEMENT FOR ALDINE LOTS. Pictured is a February 1908 advertisement from the *Jeffersonian* newspaper in Cambridge, Ohio, touting land for sale and Aldine's fig-growing potential. Land agent Eugene Robertson placed advertisements in many northern newspapers during the late 1900s and early 1910s. The ads often highlighted the easy payment terms and featured letters from Aldine farmers describing the ample crops they could grow in the warm, temperate climate. Robertson also created a multipage booklet about Aldine that same year called *Aldine in Midwinter*. This booklet presented numerous photographs of the Aldine area with a particular focus on local farming. Readers could see the many fig and satsuma orange orchards that dotted the landscape. Other pictures included the train depot, the Presbyterian church, and everyday life in the expanding community. Robertson's advertisements certainly played a large part in that growth. (Courtesy of Mark McKee.)

CAMPBELL GENERAL STORE. John Poteet bought 40 acres from Ferris Colby in 1899 and established a general store and boardinghouse along the railroad tracks. Poteet soon developed health problems and had to sell his businesses. Basil Campbell bought them in 1906. Campbell supplied Aldine's grocery and dry goods needs while his wife, Alice, ran the boardinghouse. They left Aldine in 1915. (Courtesy of Aldine ISD Mendel Heritage Museum.)

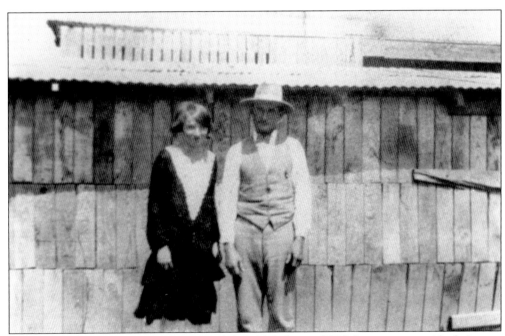

SCHLOBOHM & STOWE GENERAL STORE. Edith Schlobohm and Will Stowe pose outside their store on Hardy Road at Aldine-Bender Road. The Aldine area could boast of several general stores that offered a variety of merchandise, but for specialized purchases, Aldine shoppers often had to travel to Houston. (Courtesy of Aldine ISD Mendel Heritage Museum.)

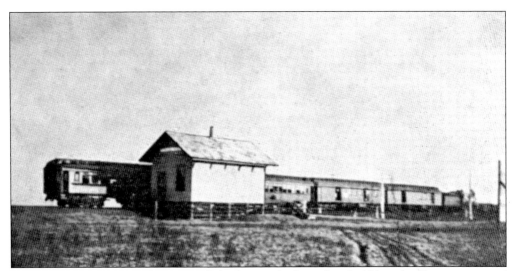

ALDINE TRAIN DEPOT. After years of pleading with the railroad, Aldine finally got a covered depot (pictured) in 1902. More of a shed than a classic depot, it at least gave riders a place to wait protected from the elements until the train arrived. Travelers purchased tickets at the nearby general store/post office. (Courtesy of Aldine ISD Mendel Heritage Museum.)

BOARDINGHOUSE. John Poteet opened a hotel/boardinghouse (pictured) and general store at Hardy and Aldine Roads (now Aldine-Bender Road) in 1902. The boardinghouse changed hands several times, eventually becoming the Barrett family residence in the 1940s, when this photograph was taken. (Courtesy of Aldine ISD Mendel Heritage Museum.)

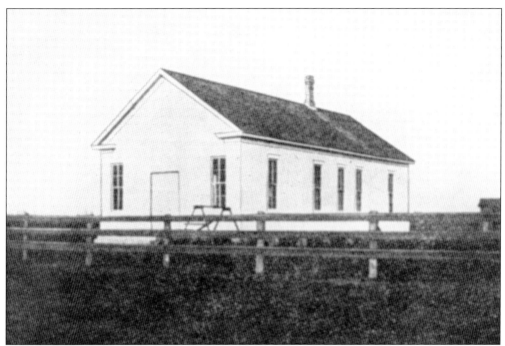

ALDINE PRESBYTERIAN CHURCH. The Aldine Presbyterian Church held its first service in 1902 and was a local institution for more than 60 years. In 1965, the congregation moved to a new site on Airline Drive. While officially a Presbyterian church, the congregation welcomed Aldiners of all denominations to use the building. A nondenominational Sunday school held classes here. (Courtesy of Aldine ISD Mendel Heritage Museum.)

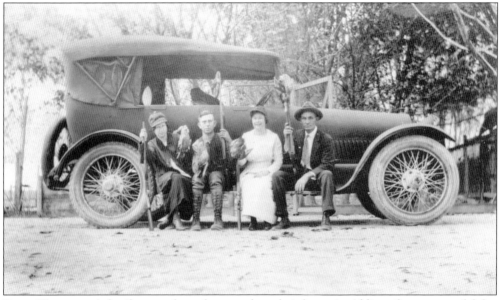

DUCK HUNTERS. A family poses for a photograph at their home in Aldine after a successful day of duck hunting. Outdoor activities like hunting, fishing, and swimming were popular pastimes in the early 20th century. People also enjoyed box suppers, ice cream socials, dances, and parlor games. School sports gained a loyal following. (Courtesy of Humble Museum.)

Two

LIFE AROUND ALDINE

The unincorporated town of Aldine traces its roots to 1889, when Ashbel Welch, a Pennsylvania railroad manager, sold 49 lots of vacant land along the I&GN Railroad south of Greens Bayou. Ferris Colby snapped up the empty lots from Welch for $10 and other considerations.

Colby was a well-traveled land speculator and real estate developer from Ohio. In 1888, he decided to call Texas home and invested heavily in Aldine-area land. He planned to resell the lots to northern immigrants wanting to move to a warmer climate.

Aldine looked to be an ideal location. The I&GN had been placing newspaper advertisements in the Midwest about resettling in Texas using the company's Lone Star Route. This line ran from Palestine to Galveston, passing through Aldine. I&GN's advertisements promised special rates for immigrants and their belongings. With flat, treeless land, Aldine appealed to farmers of all kinds. Colby laid out a town along the tracks to serve as a business hub.

Ever the salesperson, Colby sponsored special train trips to Aldine for potential settlers. He greeted passengers at the train stop, treated them to a barbecue dinner under a big tent, and offered tours. If a prospect bought a large lot outside of town, they also received a smaller town lot as part of the deal.

Between 1889 and 1906, Colby developed several subdivisions, including Aldine, Aldine Gardens, Magnolia Gardens, and Swea Gardens. Colby rightly received a lot of credit for Aldine's early growth; however, he was not the only land agent around. After his success, others, such as George Harbin and H.S. Weary, started selling land around Aldine in the late 1890s and early 1900s.

George Harbin, from Iowa, bought 1,750 acres along the railroad north of Aldine. He divided it into 10- and 20-acre plots for sale. H.S. Weary, meanwhile, advertised five- and 10-acre lots north of town where prospectors had once drilled for oil. Though not as famous as Colby, these developers and others also played a role in the early history of Aldine.

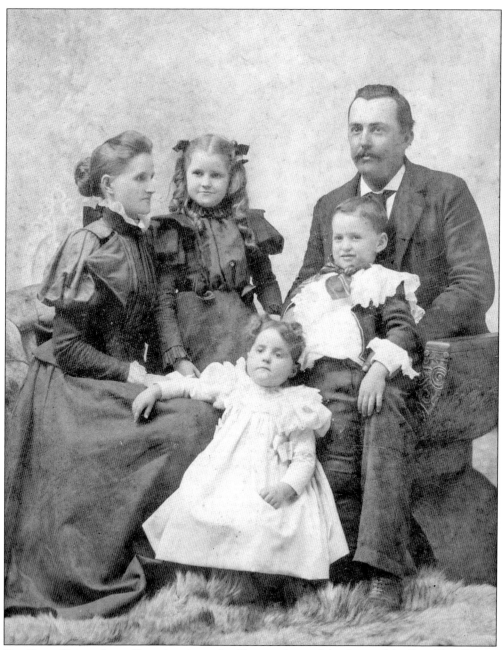

THE BERRY FAMILY. James Berry immigrated to Texas and joined the Army of the Republic of Texas in March 1836, serving as an infantry first lieutenant until 1838. He purchased a farm on Greens Bayou in 1846. Berry was one of the earliest settlers in north Harris County, living to the east of the Schlobohms. He served as a justice of the peace (1840–1853), county treasurer (1854–1857), and in other public service positions in Harris County. Berry died in 1876 following a fall from a wagon. Berry Road and Houston ISD's Berry Elementary were named in his honor following a gift of land from his children in 1909 on what would have been their father's 100th birthday. Ira Brooks bought the Berry farm in 1934 and developed Brookside Memorial Park around the old Berry Cemetery. (Courtesy of Woodson Research Center, Fondren Library, Rice University.)

THE SCHLOBOHM FAMILY. Johann and Caroline Schlobohm were among the first pioneering settlers in the Aldine/North Belt area. Johann served in the Texas army unit that stood guard over Mexican general Santa Ana after the Battle of San Jacinto. The German immigrants founded a homestead along Greens Bayou west of the modern Brookside Cemetery in 1856. (Courtesy of Aldine ISD Mendel Heritage Museum, Schlobohm Family Collection.)

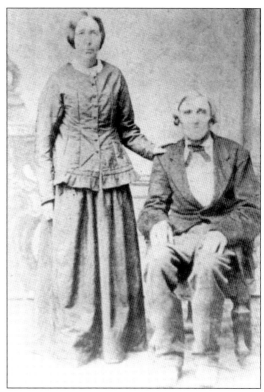

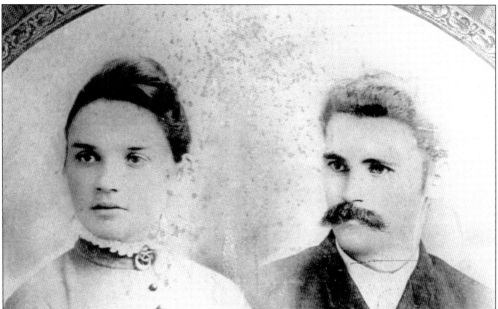

THE ANDERSON FAMILY. Carl Alfred Anderson and his wife, Tekla Edlen, were born in Sweden. They met and married in Illinois and moved to Aldine, where they established a homestead. Carl often was the first Harris County farmer to deliver strawberries to market. He became US postmaster in Aldine in 1897, served as a school trustee, and oversaw the local drainage district. (Courtesy of Aldine ISD Mendel Heritage Museum.)

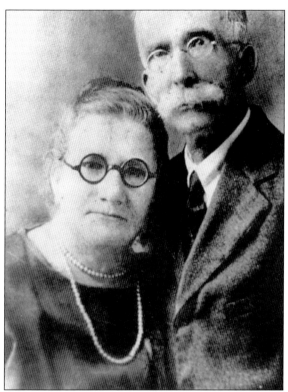

THE HENRY FAMILY. John Anthony Henry was born in the Netherlands. He met and married Mary Lucena Wilcox in Illinois. The couple later moved to Aldine and established a dairy farm, where they also raised poultry, berries, and vegetables. Henry Road was named for them. (Courtesy of Aldine ISD Mendel Heritage Museum.)

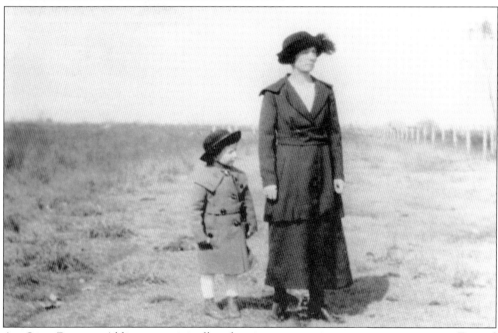

AN OPEN PRAIRIE. Aldine was originally a farming community set on an open prairie. Fig and orange groves dotted the area in the 1910s, later replaced by truck and dairy farms. Here, Clara Reeves and her daughter Virginia stand on a trail (now Reeveston Road) in 1920. (Courtesy of Aldine ISD Mendel Heritage Museum, Reeves Family Collection.)

THE REEVES FAMILY. Edwin Reeves and his wife, Callie McQueen, moved to Aldine from eastern Tennessee to set up a homestead and family. Edwin reported that the mild Aldine climate improved his wife's health, which had deteriorated in their cold former home. The locals were kind and welcomed the Reeves, he reported in a letter to Aldine land agent and promoter Eugene Robertson. Edwin quickly found work overseeing many of the fig orchards that dotted the Aldine landscape in the early 1900s. He also grew vegetables, once raising an amazing 11.5-pound beet that earned a story in the *Houston Chronicle*. His descendants became successful dairy farmers and were active in the community and its schools. They preserved much of the area's history and donated many items to the Aldine Heritage Museum. (Both, courtesy of Aldine ISD Mendel Heritage Museum, Reeves Family Collection.)

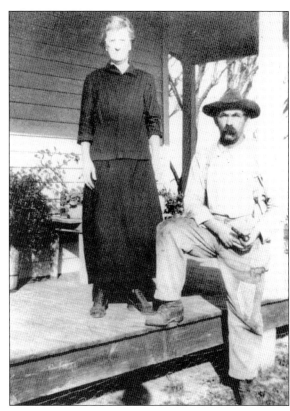

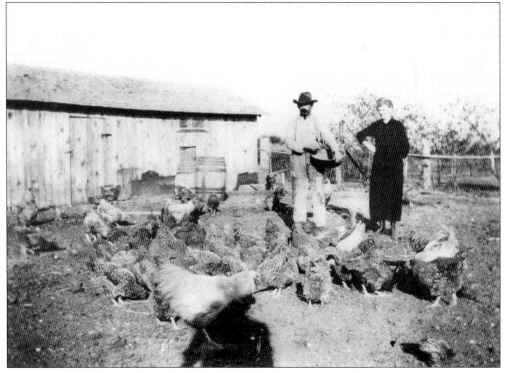

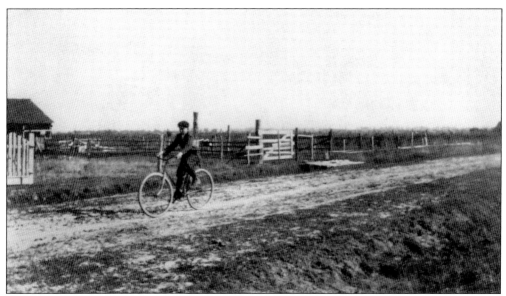

BIKING ON DIRT ROADS. A local boy has the road to himself while bicycling through rural Aldine's wide-open spaces a century ago. Young people had plenty of farm and household chores, but they did enjoy some free time. Fishing and hunting were popular outdoor activities, along with football and baseball. (Courtesy of Aldine ISD Mendel Heritage Museum, Reeves Family Collection.)

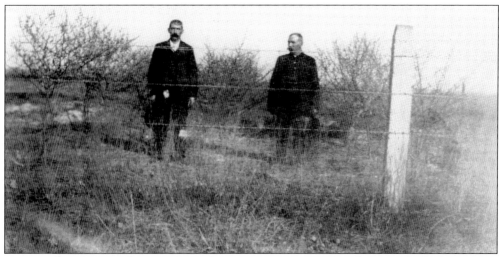

BARBED WIRE FENCE. Edwin Reeves and H.S. Reeves were caught admiring a barbed wire fence surrounding an Aldine homestead in the 1920s. Few Aldiners had fences in the early days of settlement, allowing livestock to roam free across the land. William Schlobohm put up the first fence, causing some bad feelings between neighbors. (Courtesy of Aldine ISD Mendel Heritage Museum, Reeves Family Collection.)

HORSE-DRAWN TRANSPORTATION. Aldine farmers used horses and wagons to work the land and transport produce to market. Before automobiles and trucks became widespread, farmers either shipped their wares by train or drove them into town via wagon, a trip that could take hours. (Courtesy of Aldine ISD Mendel Heritage Museum, Reeves Family Collection.)

WILLIAM H. SCHLOBOHM. Young William H. Schlobohm, a grandson of pioneer Johann Schlobohm, poses with a goat in front of the family home on Humble Road (now the Eastex Freeway) and Greens Road. Many Schlobohm descendants still reside in the Aldine area, nearly 170 years after Johann and Caroline first set up their homestead along Greens Bayou. (Courtesy of Aldine ISD Mendel Heritage Museum, Schlobohm Family Collection.)

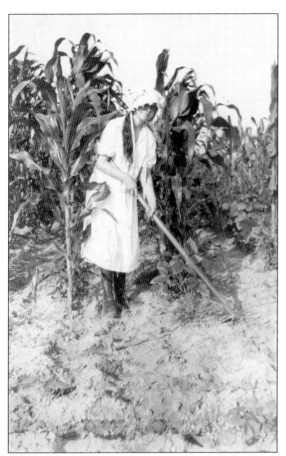

TENDING THE CROPS. Corn was one of the crops that Aldine families were able to grow. Meanwhile, satsuma oranges and magnolia figs, two early popular crops, later proved untenable. Vegetables and fruits like tomatoes, berries, pears, beets, cabbage, and turnips were more successful. Aldiners trucked their produce to the farmers market in downtown Houston. (Courtesy of Humble Museum, Irva Yancy Collection.)

TRANSPORTING CROPS TO MARKET. In the era before trucks, north Harris County farmers used horse-drawn wagons and carts to transport their wares to Houston and bring purchases back home. Such a trip, which takes about 15 to 20 minutes today on paved freeways and streets, often required four hours or more on rutted dirt roads. (Courtesy of Humble Museum, Irva Yancy Collection.)

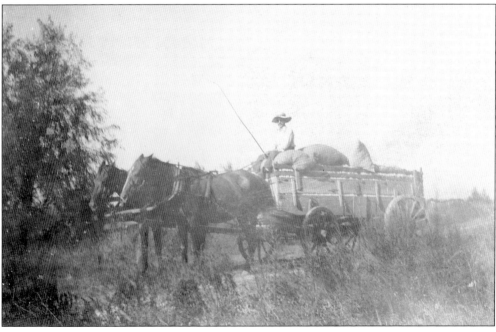

EARL REEVES AND ARCHIE ANDERSON. Aldine buddies Earl Reeves (left) and Archie Anderson are dressed in their Sunday best sometime in the 1920s. Boys at this time usually wore denim coveralls and a cotton shirt with boots or no shoes at all during the week, even to school. Girls almost always wore dresses. (Courtesy of Aldine ISD Mendel Heritage Museum, Reeves Family Collection.)

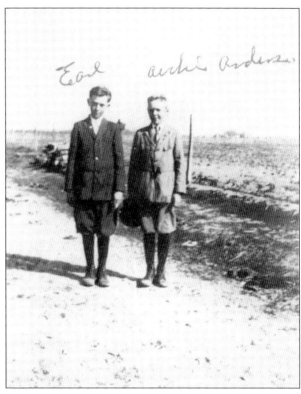

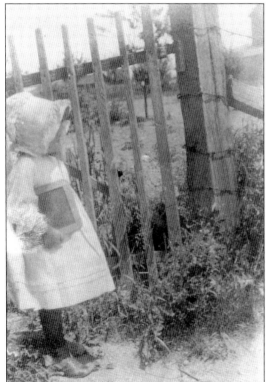

ODA CALHOUN. Oda Calhoun and her chalkboard are ready for the day's reading, writing, and arithmetic lessons. The Aldine School was a two-room schoolhouse for grades one through seven. Children of different grades and ages were taught in the same classroom. While one grade was getting instruction, the others worked on lessons. (Courtesy of Aldine ISD Mendel Heritage Museum, Reeves Family Collection.)

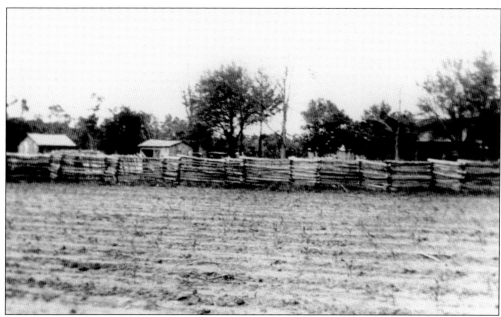

SPLIT RAIL FENCE. Johann Schlobohm's son William built this split rail fence. It was one of the first in the Aldine area and rankled neighbors used to letting cattle roam free. Schlobohm was reported to have said everyone was welcome to cross his land so long as they remembered to close the gate. (Courtesy of Aldine ISD Mendel Heritage Museum, Schlobohm Family Collection.)

THE BARRETT FAMILY. The Barrett family moved to Aldine in 1945 from east Houston. Audrey Barrett Cook, a 1953 Aldine High School graduate, had a unique home during her school years. Her family lived in the former Aldine boardinghouse on the west side of the railroad tracks at Hardy and Aldine-Bender Roads. (Courtesy of Aldine ISD Mendel Heritage Museum, Barrett Family Collection.)

Three

FARMING AND AGRICULTURE

Today, Aldine forms just another part of metropolitan Houston—a nearly indistinguishable sprawl of billboards, strip centers, used car lots, fast-food restaurants, and freeways. That was not the case in the first half of the 20th century. Aldine looked vastly different then, with open fields of crops and pastures of dairy cows dominating the landscape.

Initially, fig and citrus orchards were Aldine's primary crops. These industries died out by the 1920s due to blight, freezes, and falling demand. Truck farms and dairy farms quickly replaced the orchards.

Aldine's first dairy farmers' association started in the late 1910s, made up of people who had seen their fig and citrus orchards fail and needed a new source of income. Dairying proved to be a much better enterprise. Aldine boasted 175 dairy farms by 1939.

Life on a 1930s dairy farm was not easy, especially in the days before electricity. Dairying is a seven-day-a-week job, with little time off for leisure. Days typically began at 6:00 a.m., before sunrise. Cows needed milking, and the milk needed to be transported to a creamery in Houston. Feed had to be purchased, unloaded, and spread out in the unfenced pastures. Aldine cows were often allowed to roam free and were herded back to the farm before they wandered too far. Children helped with these activities before and after school.

Truck farms were small, family-owned businesses that raised garden fruits and vegetables sold at farmers markets. Aldine farmers grew a wide variety of produce, including vegetables like mustard greens, turnip greens, beans, cauliflower, tomatoes, eggplants, sweet peppers, and others. Strawberries and watermelons were popular fruit crops, as were pears.

Aldine farmers would then truck (drive) their produce into Houston for sale at farmers markets downtown or on Airline Drive. Most truck farmers did not make a lot of money, usually just enough to survive another day. Aldine's truck and dairy farms died out by the mid-1960s, when homebuilders and real estate developers bought the land to construct homes and neighborhoods.

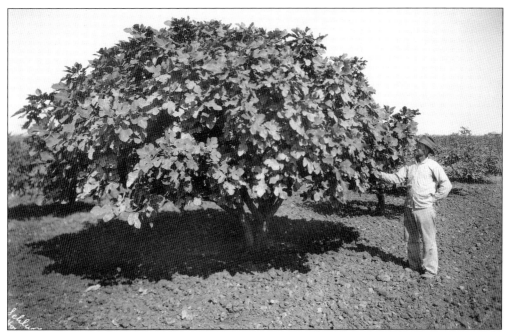

FIGS. The magnolia fig is a common fig variety with dark red, brown, violet, or black skin and white or amber pulp. It is the most popular commercial fig in the southern United States. This was the variety grown in Aldine fig orchards. (Courtesy of Houston Metropolitan Research Center, Frank Schlueter/Bank of the Southwest Collection.)

FIG ORCHARD. The magnolia fig is a large fruit with a sweet flavor. That made it a popular dessert in the early 1900s. Unfortunately for Aldine growers, the area's wet weather often meant the figs would split or turn sour as they ripened on the tree waiting to be picked. This cost orchard owners during particularly rainy years. (Courtesy of Houston Metropolitan Research Center, Frank Schlueter/Bank of the Southwest Collection.)

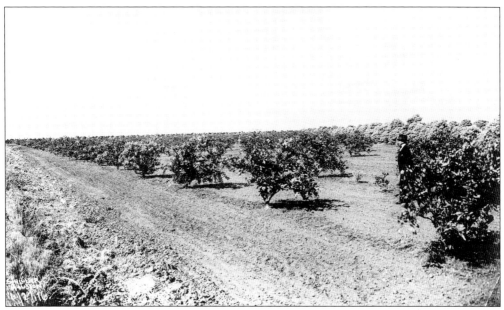

MAGNOLIA FIGS. Orchards raised magnolia figs all across the Texas Gulf Coast prairie in the early years of the 20th century. Aldine's John Carpenter entered a batch of preserved figs for the 1904 St. Louis World's Fair. After he won a silver medal, he helped create a new industry in Aldine and southeast Texas. (Courtesy of Houston Metropolitan Research Center, Frank Schlueter/Bank of the Southwest Collection.)

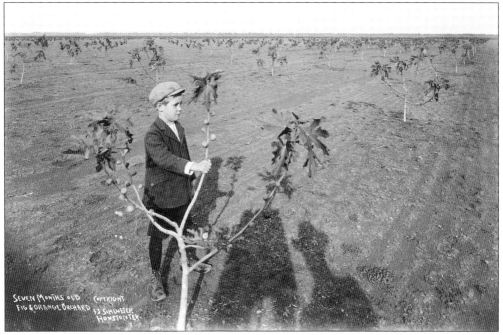

FIG FARMING. Promoters and land agents marketed Aldine across the northern United States as a place where farmers could grow magnolia figs and satsuma oranges as cash crops. It did not last long. By the 1920s, produce farms and dairies had replaced the fruit orchards. (Courtesy of Houston Metropolitan Research Center, Frank Schlueter/Bank of the Southwest Collection.)

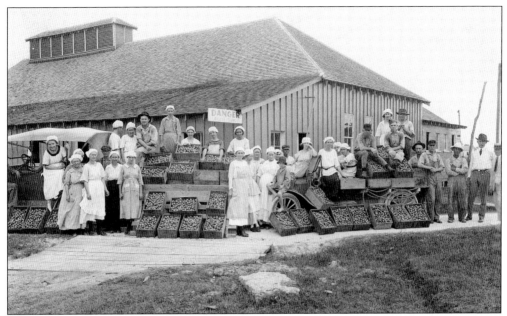

J.C. CARPENTER FIG CO. Aldine's J.C. Carpenter Fig Co. shipped three brands of skinless figs across the United States for consumption in railroad dining cars, hotels, retail stores, and wholesale grocers. The J.C. Carpenter Fig Co. marketed its preserved figs as the "aristocrat of desserts." (Courtesy of Houston Metropolitan Research Center, Frank Schlueter/Bank of the Southwest Collection.)

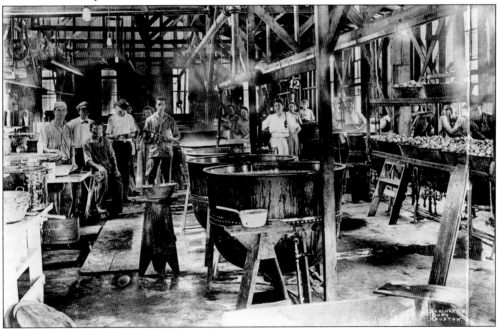

FIG FACTORY. John Carpenter was known as the "Father of the Skinless Preserved Fig Industry." He settled in Aldine and planted 10 acres of magnolia figs. At the time, it was the largest fig orchard in Texas and grew to 23 acres the following year. His fig factory was Aldine's biggest employer in the 1910s. (Courtesy of Houston Metropolitan Research Center, Frank Schlueter/ Bank of the Southwest Collection.)

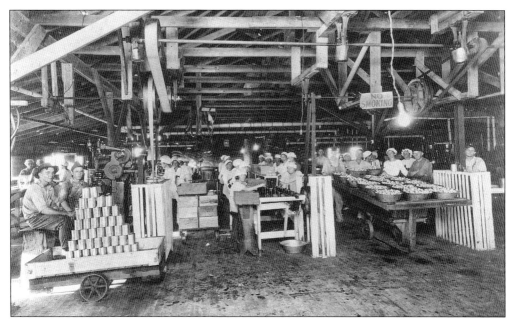

FIG FACTORY WORKERS. J.C. Carpenter Fig Co. workers prepare figs for canning and shipment to market. The company's first factory opened in Aldine in 1907. A larger one replaced it four years later. The J.C. Carpenter Fig Co. eventually boasted several similar plants along the Texas Gulf Coast at its height. (Courtesy of Houston Metropolitan Research Center, Frank Schlueter/Bank of the Southwest Collection.)

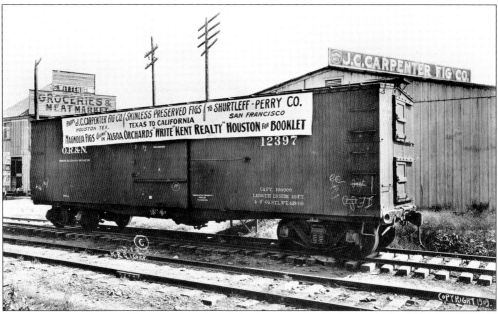

J.C. CARPENTER FIG CO. FREIGHT CAR. The J.C. Carpenter Fig Co. shipped skinless preserved figs by the trainload to stores and dining establishments across the country. The company advertised its figs as the "aristocrat of desserts." California emerged as one of J.C. Carpenter Fig Co.'s biggest markets. (Courtesy of Houston Metropolitan Research Center, Frank Schlueter/Bank of the Southwest Collection.)

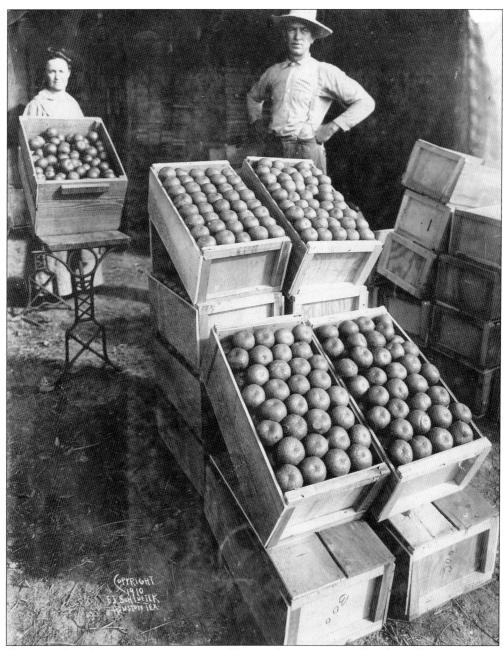

CRATES OF ORANGES. A citrus grower shows off crates of satsuma oranges for sale at a Houston farmers market in 1910. Aldine farmers and growers took their produce to downtown Houston every morning, setting up stalls at an open-air market on Smith Street at Prairie Street. In 1929, this market moved to an enclosed building located where the Wortham Center now stands. Another farmers market opened on Airline Drive in 1942, south of the modern Loop 610, giving Aldine farmers a second, closer venue to sell their wares. Most Aldine farmers never earned much at either farmers market. One admitted they were lucky if they made $5 a day. That may not sound like a lot now, but $5 in 1922 was the equivalent of around $80 in 2022. (Courtesy of Houston Metropolitan Research Center, Frank Schlueter/Bank of the Southwest Collection.)

BOXES OF GRADED FIGS. Aldine's fig industry took off after John Carpenter won a silver medal for preserved figs at the 1904 St. Louis World's Fair. Before long, fig orchards dotted the Aldine landscape, providing a ready supply for Carpenter's new fig cannery. (Courtesy of Houston Metropolitan Research Center, Frank Schlueter/Bank of the Southwest Collection.)

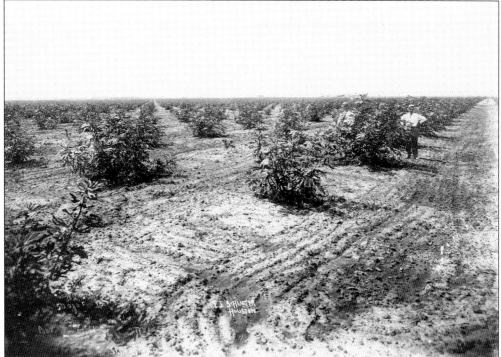

DEMISE OF THE FIG ORCHARDS. Aldine's fig industry ground to a halt during World War I, never to recover. Some blamed the demise on wartime sugar rationing, which made preserving expensive and difficult. The real reason? The magnolia fig is not suitable for a rainy, humid climate like that of Harris County. The fruit often splits and sours in wet weather. (Courtesy of Houston Metropolitan Research Center, Frank Schlueter/Bank of the Southwest Collection.)

CHICKEN FARM. Aldine children woke up at sunrise every day to take care of farm chores such as feeding animals and gathering eggs. Farmers like the Linnbruggers (shown here) used the poultry to feed their families and sold the rest to city folk and stores in Houston and Humble. (Courtesy of Humble Museum, Irva Yancy Collection.)

YARDBIRDS. Families in and around Aldine depended on agriculture for their livelihoods as there was almost no industry in the area to provide steady employment, a stark contrast to today. Now it is tough to find remnants of Aldine's agricultural past in the growing urban sprawl. (Courtesy of Humble Museum, Irva Yancy Collection.)

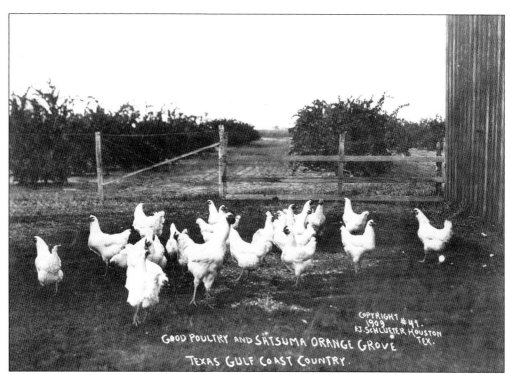

POULTRY AND ORANGES. Orange groves were once scattered across the Aldine prairie. Orchard owners believed the Texas Gulf Coast offered the perfect conditions to raise the healthful citrus fruit. Newspaper advertisements promoted Aldine's orange-growing potential across the northern United States. (Courtesy of Houston Metropolitan Research Center, Frank Schlueter/Bank of the Southwest Collection.)

ORANGES. Oranges are a popular citrus fruit—and for good reason. They are high in fiber and vitamin C. Orange juice rivals milk and coffee as a way to start a morning. Aldine orchard owners no doubt dreamed of making good money raising the fruit. But the industry faded after a freeze damaged the crop in the mid-1910s. (Courtesy of Houston Metropolitan Research Center, Frank Schlueter/Bank of the Southwest Collection.)

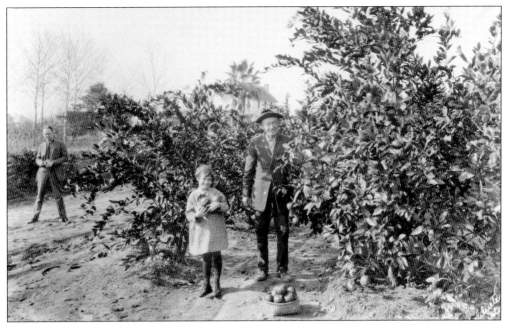

ORANGE GROVES. Aldine once boasted numerous satsuma orange groves, yielding bushels of the tangy, juicy fruit. A freeze damaged the crops in the 1910s, forcing orchard owners to switch to other crops for a living. Today, about all that remains of the once thriving industry is the name of Orange Grove Elementary School. (Courtesy of Houston Metropolitan Research Center, Frank Schlueter/Bank of the Southwest Collection.)

WATERMELON CROPS. This Aldine field stood empty when the picture was snapped, but it was not long before a bountiful crop of juicy, ripe watermelons was ready to pick for summer picnics or for sale at Houston's farmers market. (Courtesy of Houston Metropolitan Research Center, Frank Schlueter/Bank of the Southwest Collection.)

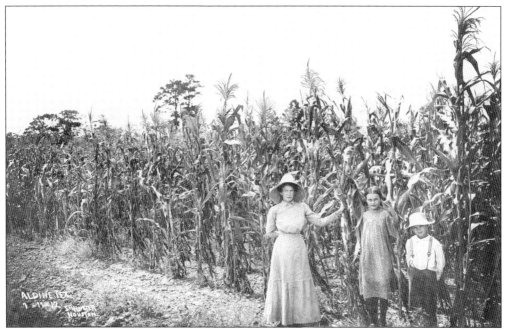

CORN STALKS. Corn stalks dwarf a mom and her children at an Aldine farm. Farms took advantage of the temperate local climate to grow up to three full crops per year, compared to just a single crop like northern farmers. (Courtesy of Houston Metropolitan Research Center, Frank Schlueter/ Bank of the Southwest Collection.)

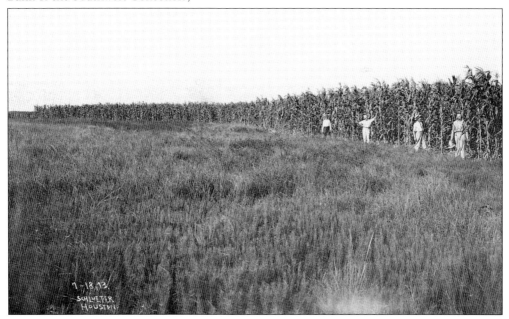

STALKERS. Corn was just one of the many crops farmers grew in Aldine's fertile soil. One local grower reported planting Irish potatoes in the spring, corn and stock peas in the summer, and finishing the growing season with turnips, beets, and carrots, giving him three cash crop plantings in a single year. (Courtesy of Houston Metropolitan Research Center, Frank Schlueter/Bank of the Southwest Collection.)

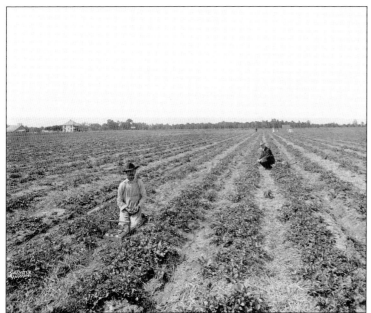

HARVEST. Local farmers take a picture break during harvest time. Many landowners had to hire outside help to pull in their bounty. Real estate agents promoted Aldine as having rich, easy-to-cultivate soil where anyone could make an honest, independent living without regret. (Courtesy of Houston Metropolitan Research Center, Frank Schlueter/Bank of the Southwest Collection.)

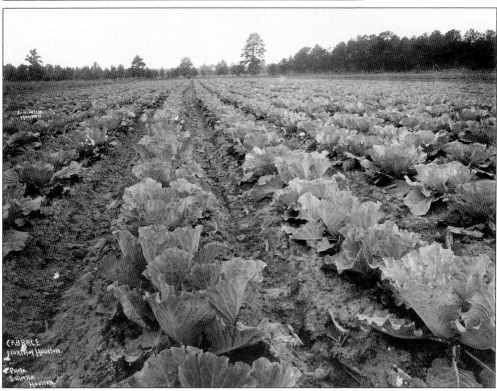

CABBAGE AND LETTUCE CROPS. Aldine farmers grew a wide variety of nutritious vegetables. In addition to the cabbage and lettuce shown here, one could also find radishes, beets, carrots, onions, and tomatoes at truck farms across the prairie. Fruits included watermelons, strawberries, dewberries, and pears. (Courtesy of Houston Metropolitan Research Center, Frank Schlueter/ Bank of the Southwest Collection.)

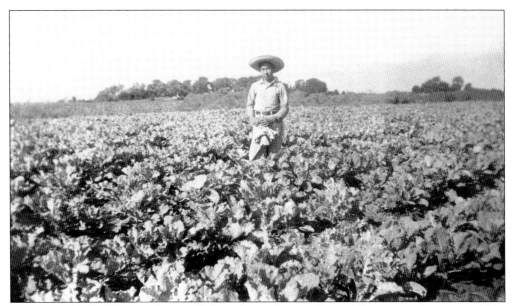

THE OKABAYASHI FAMILY. Minoru Okabayashi was born in Japan. He came to America in 1915, settling first in California and then in the Aldine area in the 1930s. He and his wife, Yoshimi, raised nine children on their 200-acre farm on Gulf Bank Road, on what is now part of Northline Terrace. (Courtesy of Aldine ISD Mendel Heritage Museum.)

THE OKABAYASHI FARM. Employing more than 50 laborers during peak farming season, the Okabayashis grew tomatoes, collard greens, turnips, radishes, beets, broccoli, cabbage, and spinach. Son Tsutomo "Tommie" Okabayashi was in the Future Farmers of America chapter at Marrs High School and helped introduce new techniques to the family farm. (Courtesy of Aldine ISD Mendel Heritage Museum.)

CASH COWS. In semirural Aldine, dairy farming was the top industry in the 1930s, 1940s, and 1950s. The area was home to 175 dairies in 1939. Cows often wandered freely and were not penned or fenced in. They sometimes became a road hazard, blocking traffic. (Courtesy of Aldine ISD Mendel Heritage Museum.)

DAIRY FARMING. Top dairy producers included the Fuchs Dairy, which produced 600 gallons per day; the Saathoff Dairy on Aldine-Westfield Road, just north of Humble-Westfield Road, which developed a reputation as top dairy cow breeders; and the Francis Dairy in the northeast. (Courtesy of Aldine ISD Mendel Heritage Museum.)

Four

HOUSING AND TRANSPORTATION

As the 20th century dawned, people rode horses to move around Aldine or took trains for longer trips. Travel was slow. Affordable, mass-produced autos appeared in the 1910s, and Harris County began a road construction program, giving drivers a way to get places.

Early north/south roads consisted of Houston-Conroe County Road (now Hardy Road), Aldine-Westfield Road, East Montgomery Road (Airline Drive), Humble Road (Interstate 69), and Stuebner Airline Road (Veterans Memorial Boulevard). The east/west roads were Aldine-Bender Road (east of Aldine), Aldine Road (west of Aldine), Greens Road, and Humble-Westfield Road (FM 1960, a farm-to-market road).

Three local roads received a federal highway designation: East Montgomery Road, which became US 75 in 1927; Humble Road, US 59 in 1942; and North Shepherd Drive, US 75 in 1944, replacing East Montgomery Road from Stuebner Airline Road to Aldine Road.

In the 1950s, the country started building a national network of limited-access, high-speed interstate highways. Texans called these "freeways." US highways around major cities also received upgrades to freeways. Two federal freeways and a state one debuted around Aldine, while Harris County constructed a tollway. Completion dates included Interstate 45 in 1963 (North Freeway, which replaced North Shepherd Drive and East Montgomery Road), US 59 in 1970 (Eastex Freeway, which replaced Humble Road), Beltway 8 in 1984 (North Belt, which replaced frontage roads and overpasses), and the Hardy Toll Road in 1988. In 2012, the Eastex Freeway (US 59) was redesignated Interstate 69.

Freeways paved a path for rapid growth. In 1956, Raleigh Smith started Hidden Valley along the soon-to-be-built North Freeway. Hidden Valley offered something new: tract homes, which used predesigned floor plans that could be built quicker and cheaper than custom houses.

Tract homes rapidly sprang up during the mid-1960s. High Meadows boasted 2,000 houses. Hidden Valley finished with 1,250. Other neighborhoods with 500 homes or more included Fairgreen, Fallbrook, Imperial Valley, and Oakwilde. Aldine Arms opened as the area's first two-story, garden-style apartment complex in 1963 on Aldine Mail Route, west of the Eastex Freeway. Over the next 15 years, developers built many more complexes, eventually flooding the market. By 1985, streets, homes, and apartments had replaced Aldine's open prairie, truck farms, and dairies.

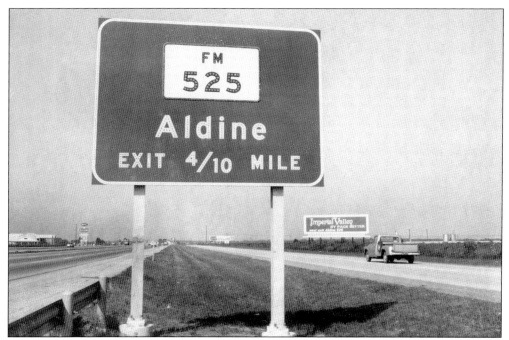

FREEWAYS. Aldine went through a rapid growth period during the 1950s and 1960s. Houston's new freeway system fueled this boom. The Eastex Freeway on the east side of Aldine and the North Freeway on the west cut a trip from Aldine to downtown Houston from nearly an hour to just 10 to 20 minutes. (Courtesy of Aldine ISD Mendel Heritage Museum.)

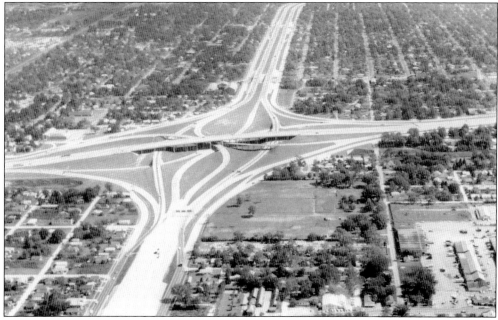

THE NORTH FREEWAY. Originally designated as US 75, the North Freeway was built quicker than any other Houston freeway, in just three years. Until the 1970s, the North Freeway (by then Interstate 45) served mostly low- and middle-income areas and was largely devoid of commercial development. (Courtesy of Aldine ISD Mendel Heritage Museum.)

THE EASTEX FREEWAY. The Eastex Freeway was Houston's second freeway to open to traffic, and it received its name through a citywide contest. Work on the freeway began in 1952. The freeway was completed from downtown to Will Clayton Parkway by March 1970. (Courtesy of Houston Metropolitan Research Center, Houston Post Photograph Collection.)

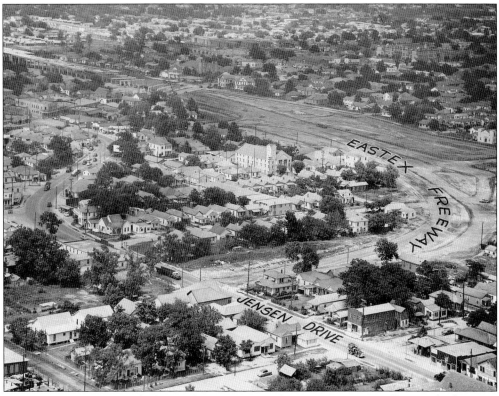

JENSEN DRIVE FREEWAY. The Eastex Freeway's original route ran just east of Jensen, leading to it being informally dubbed the "Jensen Drive Freeway." Starting in the 1990s, the antiquated Eastex Freeway underwent reconstruction, was greatly expanded to allow for more traffic, and was rebuilt as a superhighway to the Grand Parkway. (Courtesy of Houston Metropolitan Research Center, Houston Post Photograph Collection.)

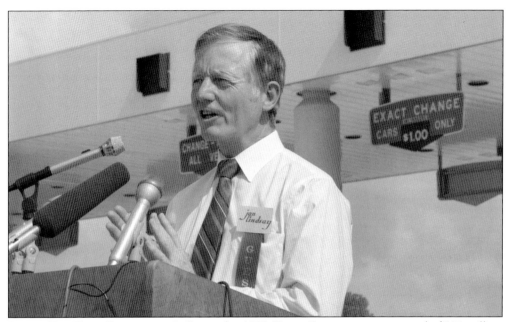

HARDY TOLL ROAD DEDICATION. In September 1983, Harris County voters approved a $900 million bond to build a series of toll roads, including the 21.6-mile, six-lane Hardy Toll Road running from Loop 610 North to Montgomery County. Construction began in September 1984. Former AISD superintendent W.W. Thorne oversaw construction. The tollway's northern section, extending from Beltway 8 to the Montgomery County line, opened in September 1987. The southern section, from Loop 610 North to Beltway 8, followed in June 1988. Harris County judge Jon Lindsay (above) was the first one through the Aldine Toll Plaza. The toll road authority held a dedication on June 28, 1988, featuring Lindsay, Harris County Toll Road Authority executive director Wesley Freise, county commissioner Elizabeth Ghrist, and Fern Lyons, wife of county commissioner E.A. "Squatty" Lyons. (Both, courtesy of Houston Metropolitan Research Center, Houston Post Photograph Collection.)

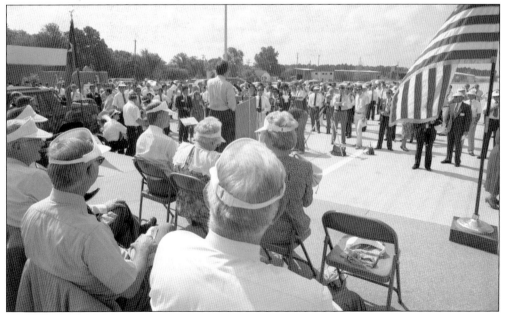

THE NORTH BELT. The North Belt opened in 1969 as a frontage road with overpasses. Freeway lanes followed in 1984. The North Belt connects the North and Eastex Freeways and serves as the primary route to George Bush Intercontinental Airport. Designated Beltway 8 by the state, it is a separate highway from the Sam Houston Tollway. Motorists need not pay a toll. (Courtesy of Houston Public Library, Houston Metropolitan Research Center.)

BELTWAY 8. Harris County originally proposed an Outer Loop in the late 1930s. But after beginning construction in the 1960s, it realized the task was too costly and difficult and requested assistance from the Texas Department of Transportation. The state took over the project and redesignated the Outer Loop as Beltway 8 in 1969. (Courtesy of Aldine ISD Mendel Heritage Museum.)

SAM HOUSTON TOLLWAY. The Harris County Toll Road Authority opened a 13-mile segment from the North Freeway to the Northwest Freeway in June 1990. The tollway (then running 28 miles from the North Freeway to the Southwest Freeway) was renamed the Sam Houston Tollway. The section between the Eastex Freeway west to Ella Boulevard remained as the North Belt and is toll free. (Courtesy of Aldine ISD Mendel Heritage Museum.)

INTERNATIONAL & GREAT NORTHERN RAILROAD. In 1871, the Houston & Great Northern Railroad laid tracks 55 miles north from Houston to New Waverly. What is now Aldine sat along the route. Two years later, the H&GN joined forces with the International Railroad to become the I&GN, which merged into parent Missouri-Pacific in 1956. (Courtesy of Houston Metropolitan Research Center, Frank Schlueter/Bank of the Southwest Collection.)

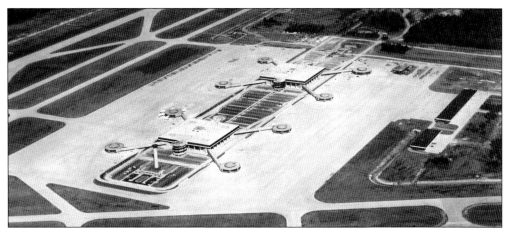

NEW AIRPORT. Houston business owners and civic leaders formed Jet Era Ranch Corp. in 1957 as a front. They aimed to quietly buy nearly 3,000 acres of north Harris County timberland and dairy farms for a future city airport. A typo on a planning document misspelled Jet Era as Jetero, which became the name of the road leading to the airport. (Courtesy of the 1940 Air Terminal Museum.)

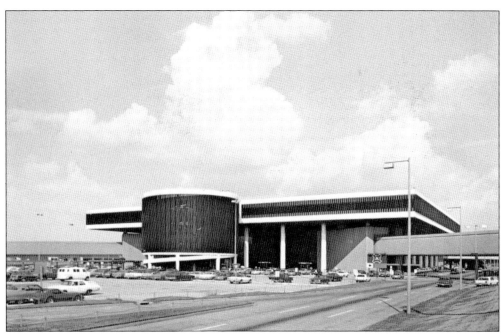

HOUSTON INTERCONTINENTAL AIRPORT, 1969. The City of Houston annexed the airport area in 1965. Houston Intercontinental Airport, the facility's original name, was scheduled to start service in 1967, but design changes, cost overruns, and construction delays pushed the opening back to June 1969. (Courtesy of the 1940 Air Terminal Museum.)

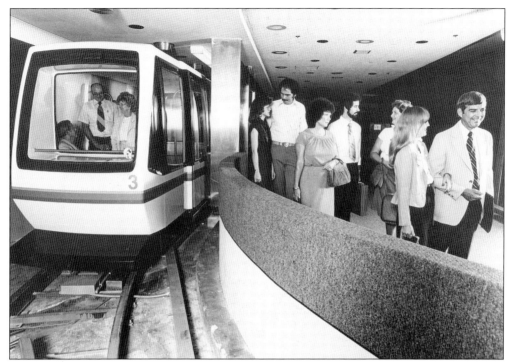

WALT DISNEY–BUILT TRAIN. The interterminal train, the first such train put into operation at an airport, provided underground transportation for passengers from Terminal A to Terminal B. An upgraded train, built by Walt Disney Transportation Systems, opened on August 17, 1981. It is the only people mover built by the Walt Disney Company outside of a Disney property. (Courtesy of Houston Public Library, Houston Metropolitan Research Center.)

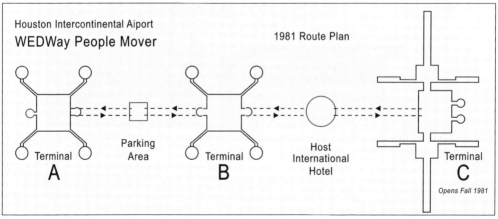

INTERTERMINAL TRAIN. The updated interterminal train travels between Terminal A, Terminal B, the Marriott Hotel, and Terminal C. The train's efficiency is impressive, with a new train car arriving every 3.5 minutes. The route was expanded to a two-mile circuit in 1990. (Courtesy of Dr. Robert Meaux.)

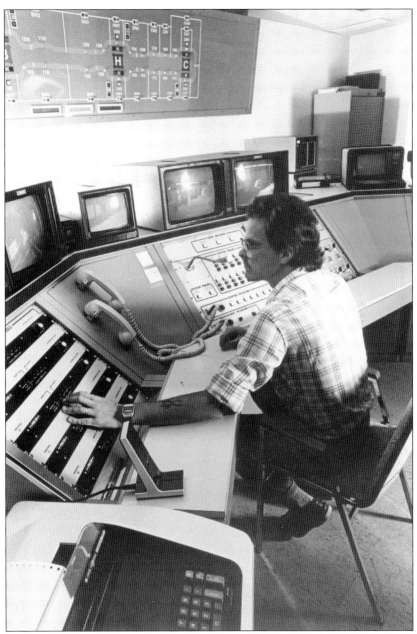

TRAIN CONTROL BOOTH, 1981. The interterminal train is an impressive system and is very efficient at moving passengers. Now more than 40 years old, the train is becoming antiquated, and it is difficult to find replacement parts. In 1999, the airport added an aboveground train system to help move passengers between Terminal B and Terminal C. The system was expanded over the years and now services Terminals A, B, C, and D. The system was initially known as TerminaLink but was renamed Skyway in 2015. Skyway works within the secure areas of the airport (for passengers who have already gone through the security checkpoints), while the interterminal train (now known as Subway) works outside security checkpoints. In 2019, the City of Houston began a process to look for a replacement for the interterminal train. (Courtesy of Houston Public Library, Houston Metropolitan Research Center.)

AIRPORT HOTEL UNDER CONSTRUCTION. A stylish hotel was added to the airport site next to the original two terminals. Host Hotels & Resorts built the hotel and leased the land from the City of Houston. The interterminal train was expanded to connect the hotel to the terminals. (Courtesy of Aldine ISD Mendel Heritage Museum.)

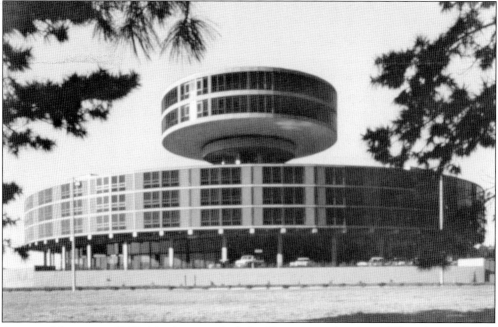

AIRPORT MARRIOTT, 1981. Marriott acquired the Host airport hotel in 1981 and immediately upgraded the facility, including the addition of a 230-room tower in 1982. The hotel now has 573 rooms, a restaurant and bar, concierge lounge, coffee shop, health club, sundry shop, and conference center. (Courtesy of Humble Museum.)

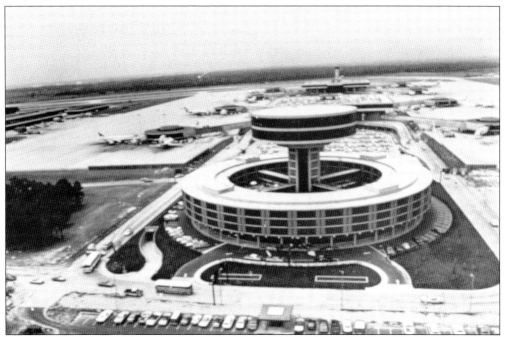

GEORGE BUSH INTERCONTINENTAL AIRPORT. The City of Houston renamed the airport in 1997 to George Bush Intercontinental Airport to honor George H.W. Bush, the 41st president of the United States, who called Space City home. The airport has five runways and five terminals, and handles over 33 million passengers each year. (Courtesy of the Humble Museum.)

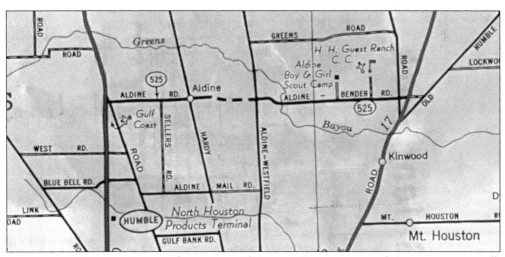

GULF COAST AIRPORT. Prior to the opening of Houston Intercontinental Airport, many small, privately owned airports were scattered around Harris County. In the Aldine area, these included the Gulf Coast Airport run by Tom Beal (near West Road and Airline Drive) and Humble Airport (between the Eastex Freeway and the H & H Guest Ranch). (Courtesy of Houston Public Library, Houston Metropolitan Research Center.)

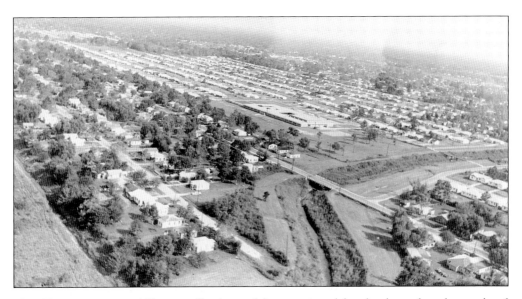

NEW NEIGHBORHOODS. Aldine rapidly changed from semirural farmland to a densely populated urban community starting in the early 1960s. Neighborhoods sprung up seemingly overnight everywhere, providing reasonably priced homes for families wanting to live just 10 to 20 minutes from downtown Houston or close to the new airport as it neared completion. In 1968, more than 4,000 homes were under construction in Arbor Oaks, Chateau Forest, Colonial Hills, Fairgreen, Fountain View, Green Ridge North, Hidden Valley, High Meadows, Imperial Valley, Inverness Forest, Inwood Forest, Memorial Hills, Northwest Manor, Oakwilde, Sequoia Estates, Sheraton Oaks, Willow Run, and Woodland Trails. (Both, courtesy of Aldine ISD Mendel Heritage Museum.)

HIDDEN VALLEY.
Located off North
Shepherd Drive (soon to
be the North Freeway)
and Gulf Bank Road,
Hidden Valley was
developed by Raleigh
A. Smith and Son.
The first homes in
this large 1,400-home
development opened in
November 1956. Raleigh
A. Smith and Son
marketed Hidden Valley
to families wanting
room to grow outside
the city. (Courtesy of
Aldine ISD Mendel
Heritage Museum.)

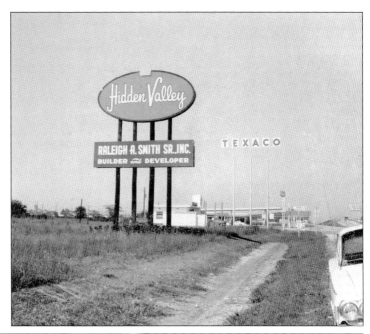

SMITH'S HIDDEN VALLEY NEIGHBORHOOD. Built by Raleigh A. Smith and Son, Hidden Valley represented a $23 million investment. Raleigh Smith entered the home development business after a 30-year career with the Southern Pacific Railroad. His son, a graduate of Rice University, joined him after a three-year stint in the US Navy. (Courtesy of Aldine ISD Mendel Heritage Museum.)

NORTHLINE TERRACE. Located off the North Freeway at Gulf Bank Road, Suburban Homes started Northline Terrace in 1964. Northline Terrace was one of many Suburban Homes neighborhoods around Aldine. Homes were sold between $11,000 and $15,000, making it an affordable alternative to the pricier Hidden Valley across the freeway while offering many of the same benefits. (Courtesy of Aldine ISD Mendel Heritage Museum.)

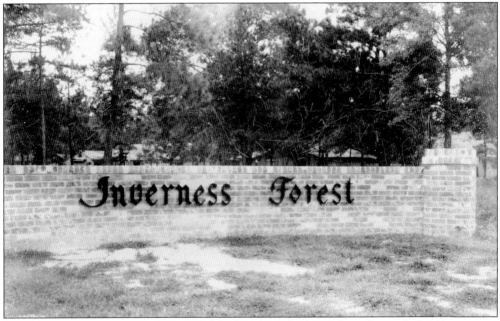

INVERNESS FOREST. This 600-home neighborhood was built in a heavily wooded, 261-acre tract just east of the North Freeway on FM 1960. It was the project of developers Donald McGregor and Donald McGregor Jr., with a $13 million investment. The first section opened in the summer of 1965. (Courtesy of Aldine ISD Mendel Heritage Museum.)

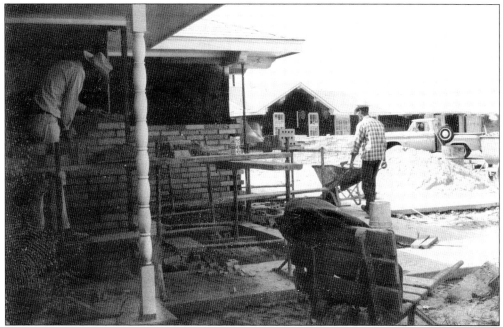

HIGH MEADOWS. Robert Vernon King, son of legendary Houston developer C.E. King, established High Meadows in the mid-1960s. King purchased 93 acres on Aldine Mail Route, taking advantage of the newly constructed Eastex Freeway for easy access to downtown. The survey and platting were done by Robert M. Atkinson & Associates. (Courtesy of Aldine ISD Mendel Heritage Museum.)

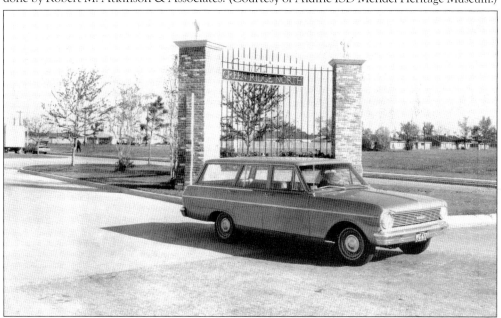

GREEN RIDGE NORTH. Started in 1966, Green Ridge North was one of the first Aldine neighborhoods to have deed restrictions. Developer Harold P. Hill's advertisements boasted of schools, churches, playgrounds, a swimming pool, streetlights, concrete streets, curbs, gutters, and a shopping center. In September 1969, a Mobil Corp. pipeline exploded within the neighborhood, destroying 15 homes and injuring 10 people. (Courtesy of Aldine ISD Mendel Heritage Museum.)

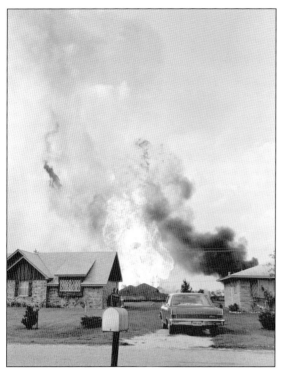

PIPELINE EXPLOSION, 1969. A loud roar ripped through the late Tuesday afternoon air on September 9, 1969. Cars on Airline Drive stopped in confusion, and students outside Aldine High School ducked for cover. Why? A 14-inch Mobile Corp. natural gas pipeline under Green Ridge North ruptured around 4:00 p.m., sending a fireball 200 feet into the sky and destroying 15 homes and injuring 10 people. The blast shattered windows a mile away. Flames reaching 800 degrees melted iron and steel. The explosion created a 60-foot-by-30-foot crater five feet deep on Kaler Road. Alert utility crews spotted something amiss and evacuated residents moments before the explosion, saving many lives. Several homeowners were unaware a gas pipeline existed so close. Homeless residents were moved to the Field Inn for shelter. (Both, courtesy of Houston Metropolitan Research Center, Houston Post Photograph Collection.)

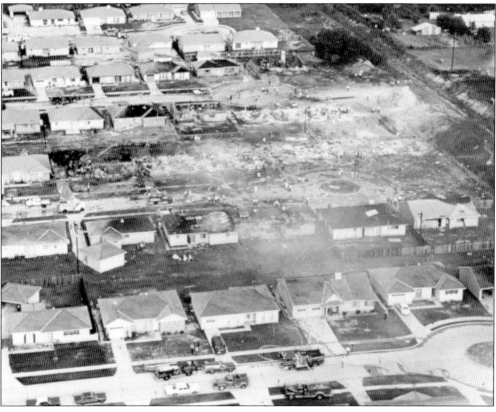

Five

COMMON SCHOOL DISTRICT 29

After the Texas Revolution, education was left to individual families or local churches. Texas set up its first system of state school funding in 1876. The first "free" (state-supported) schools appeared in Harris County that year.

County commissioners created Westfield School Community No. 1 in September 1876, six miles north of Aldine along the I&GN Railroad. The school community erected a small, one-room building with financial support from the county. It was open to any white child, regardless of where they lived, free of charge. A similar school community—Durdin No. 13—was formed in December 1876. It ran the Higgs School on Lee Road near Garner's Bayou.

In 1884, Texas counties formed geographically bound school districts to replace the earlier loosely defined school communities. Harris County Commissioners Court thus established Common School District 29 (CSD 29) to serve the area south of Cypress Creek, which included most of the future Aldine area. The Westfield and Higgs schools joined CSD 29.

The 1884 law also mandated segregation in education. White and black children could not attend the same schools. The law called for separate but equal facilities for blacks. CSD 29 built segregated schools in Westfield and Higgs not far from their white counterparts.

Whether white or black, each schoolhouse consisted of a single room. Students attended class with pupils from all other grades. Children ranged from 6 to 16 years of age, and the grades went from first to seventh. The teacher taught several grades simultaneously and divided time between them. While first graders, for example, received instruction, the others worked silently on assignments until it was their lesson time.

CSD 29 survived on a shoestring budget of state and county funds supplemented by a meager district property tax. A three-person locally elected board managed daily operations, subject to county oversight. In 1932, CSD 29 operated the white Aldine, Brubaker, Hartwell, and Higgs schools and the black Higgs, Humble, and Westfield ones.

By the mid-1930s, parents sought a greater voice in their children's educations. Their votes approved the creation of the Aldine Independent School District (AISD) in May 1935, ending CSD 29's 51-year existence.

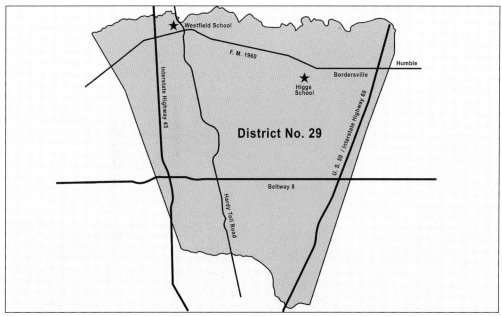

BEFORE ALDINE ISD. The first Aldine-area schools were Westfield and Higgs, which opened in 1876 as part of school communities. In 1884, commissioners divided Harris County into common school districts and assigned these two schoolhouses to Common School District 29, which eventually became the Aldine Independent School District. (Courtesy of Dr. Robert Meaux.)

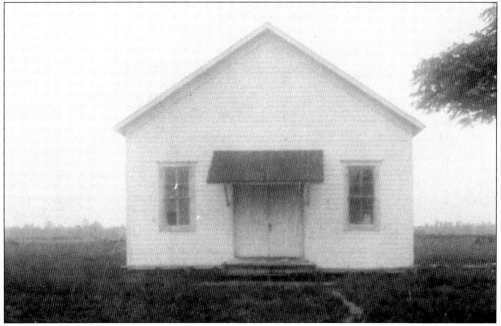

NEW SCHOOLS. In 1898, CSD 29 added two new schools. Aldine, pictured here, was located in the heart of the newly established town, near the present-day intersection of FM 525 and Hardy Road. Hartwell was on Aldine-Westfield Road across from the present-day North Harris campus of Lone Star College. (Courtesy of Harris County Public Library Archives.)

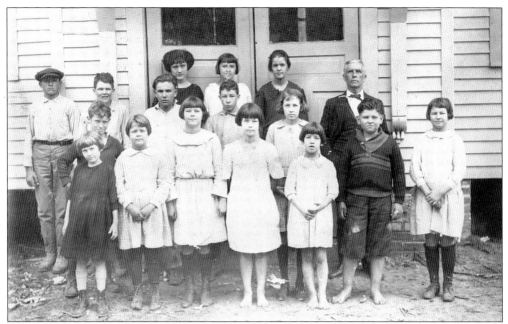

HIGGS SCHOOL. Opened in 1876 as part of the Durdin School Community, Higgs became part of CSD 29 in 1884. Pleasant Humble was one of the original school trustees. The one-room schoolhouse was on Lee Road just south of Humble-Westfield Road (now FM 1960). (Courtesy of Humble Museum.)

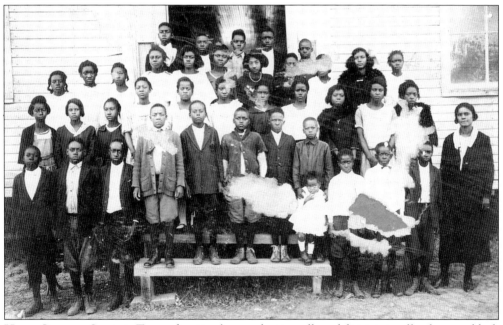

HIGGS COLORED SCHOOL. Texas education laws at the time allowed districts to offer classes to black students, but whites and blacks could not attend the same school. Only half of Harris County common school districts provided schools for blacks. CSD 29 was one such district, educating blacks at the one-room Higgs Colored School. The earliest record of the school dates from 1886. (Courtesy of Humble Museum.)

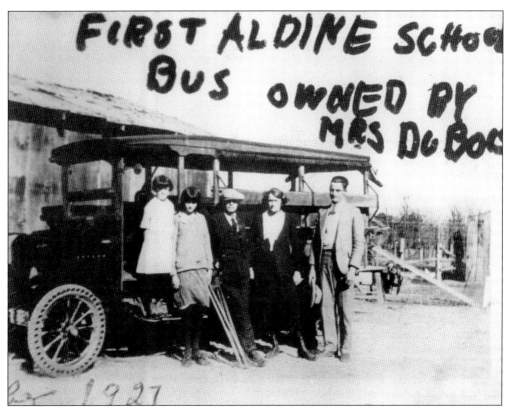

MRS. DUBOSE'S SCHOOL BUS. CSD 29 was physically a large school district, but had only a few widely separated schools. Getting students to class was a big issue in an era with few automobiles. Common school districts contracted with private individuals who would operate a bus service on the district's behalf for a price. This CSD 29 bus was owned and operated by a Mrs. DuBose. (Courtesy of Aldine ISD Mendel Heritage Museum.)

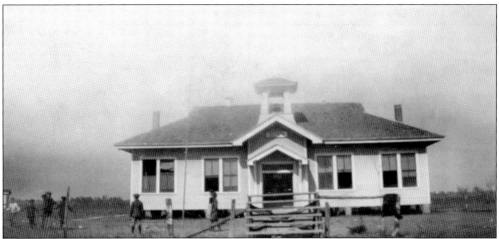

SCHOOLHOUSE BOND, 1910. In February 1910, CSD 29 voters successfully passed the district's first schoolhouse bond. The $8,000 bond authorized the building and equipping of three frame schoolhouses. The bond passed by a vote of 14-0. Pictured here is the new Aldine School, built by contractor Edwin Harwell. (Courtesy of Humble Museum.)

NEW SCHOOL BUILDINGS. Contractor Edwin Harwell won the bid to build new wooden schoolhouses paid for from the $8,000 schoolhouse bond. In the summer of 1910, three of the district's schoolhouses were funded by the bond, including the Aldine School, the Higgs School (pictured here), and the Hartwell School. Harwell used the same floor plan, so all three schoolhouses looked alike. (Courtesy of Humble Museum, Irva Yancy Collection.)

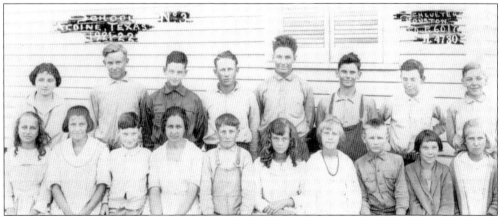

ALDINE SCHOOL CLASS, 1921. Throughout the 1920s, the district showed a small increase in the student population, growing from 230 students in 1910 to 300 in 1929. Most of the district's efforts during this time went to improving facilities, instruction, and hiring better teachers. (Courtesy of Aldine ISD Mendel Heritage Museum.)

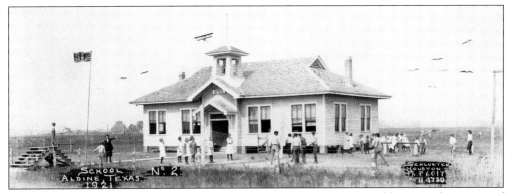

ALDINE SCHOOL, 1921. In the 1920s, Houston photographer Frank J. Schlueter took pictures of many schools in Harris County. He inserted a biplane and seagulls into each picture to make the image more interesting. Many were sold as postcards throughout the Houston area. This was his photograph of the Aldine School in 1921. (Courtesy of Aldine ISD Mendel Heritage Museum.)

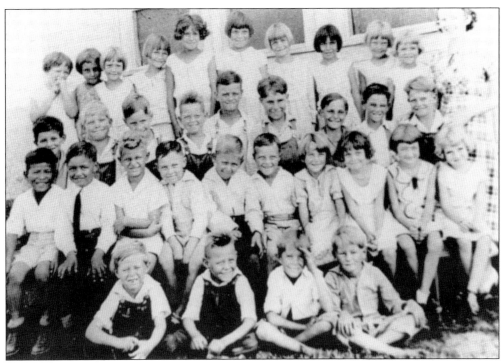

BRUBAKER SCHOOL, 1932. Built in 1924, the Brubaker School was on Blue Bell Road at East Montgomery Road (now Airline Drive). It was a two-room frame building. Elvira Riley was the first teacher. The school closed in 1933 when students were sent to the new Marrs School in Aldine. Pictured here is the first-grade class from 1932. (Courtesy of Aldine ISD Mendel Heritage Museum.)

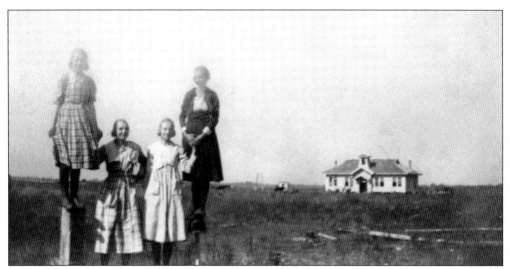

SCHOOL IN A FIELD. Irva Linnbrugger and friends pose in front of the Aldine School in CSD 29. The school stood in the middle of a large field off Aldine Road (today known as FM 525/Aldine-Bender Road). The Investex Credit Union now occupies the site. (Courtesy of Humble Museum, Irva Yancy Collection.)

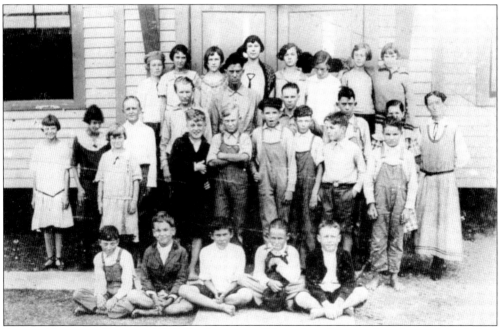

ALDINE GRAMMAR SCHOOL, 1924. Students sit still for a class photograph in front of the Aldine grammar school. A 1921 report card showed that seventh graders at the school studied arithmetic, civics, grammar, spelling, history, and agriculture. The typical school year ran for eight months, from mid-September to mid-May. (Courtesy of Aldine ISD Mendel Heritage Museum.)

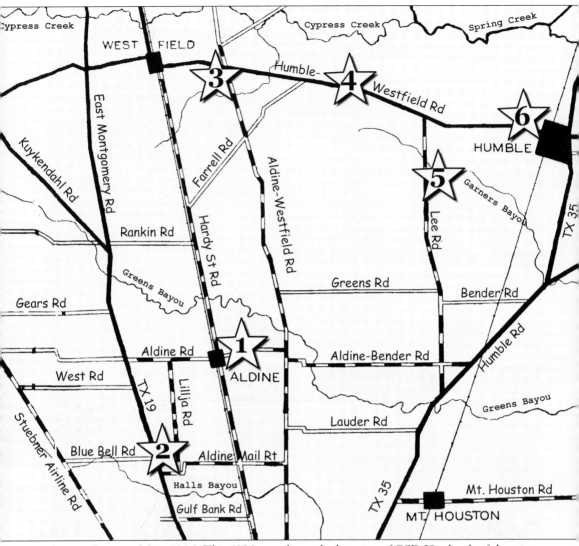

ALDINE SCHOOLS MAP, 1926. This 1926 map shows the location of CSD 29 schools of that time, including: (1) Aldine School, (2) Brubaker School, (3) Westfield School, (4) Westfield Colored School, (5) Higgs School, and (6) Humble Colored School. (CSD 29 was paying Humble ISD to educate its black students at the Humble ISD Colored School.) CSD 29's six schoolhouses were spread out over a large geographic area. In addition to having to pay for teachers and staff at six schools, the district was also expending funds on transportation, such as buses, fuel, and drivers. The high cost of operating these schools and transporting students across the large district each day strained the district's meager budget. CSD 29 decided to consolidate its schools in one central location a few years later. (Courtesy of Mark McKee.)

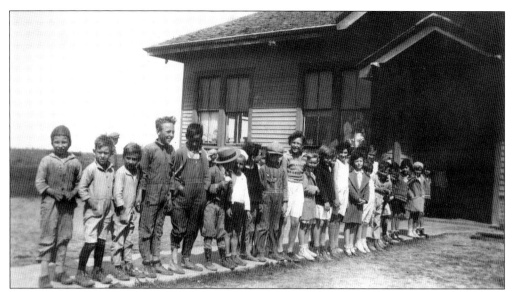

SCHOOL AND COUNTY LIBRARY. The Aldine School was a county public library station from 1921 to 1943. This often was the only way rural students could access books. Sometimes, however, they forgot to return the borrowed items, leading the county to close the library until enough books were brought back. After 1943, a bookmobile served the community until the 1950s. (Courtesy of Harris County Public Library Archives.)

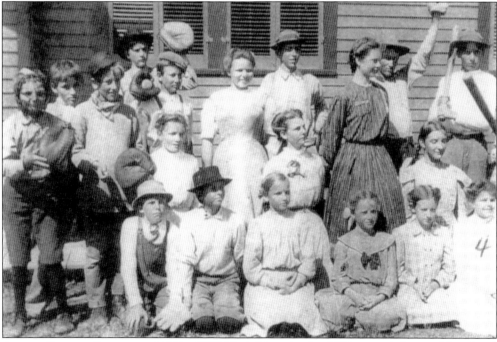

ALDINE SCHOOL STUDENTS, 1920S. CSD 29 children in the 1920s attended one of four local primary schools for grades one through seven. There were no junior highs or middle schools. CSD 29 did not offer high school classes—grades 8 to 11—in the late 1920s. Instead, the district bused white secondary students to Humble's Bender High School or Houston's Jefferson Davis High School. (Courtesy of Aldine ISD Mendel Heritage Museum.)

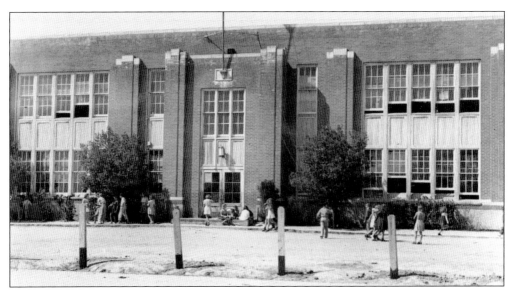

MARRS SCHOOL. In 1933, CSD 29 closed its five white primary schools and moved students to a central campus: the Marrs School. Named for the former state superintendent of public instruction, Starlin Marion Newberry Marrs, it housed grades 1 through 11. The school was at the corner of Aldine-Westfield Road and Aldine-Bender Road, near the geographic center of the district. (Courtesy of Aldine ISD Mendel Heritage Museum.)

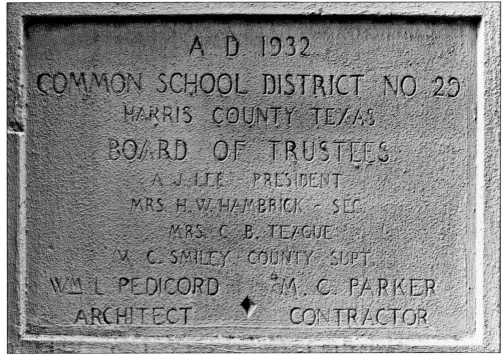

MARRS SCHOOL DEDICATION PLAQUE. With construction starting in 1932, CSD 29 intended the Marrs School as a way to consolidate teachers and students into a central location. The building was later modified to become the Ellen B. Lane Center. AISD demolished the building in 2016. (Courtesy of Aldine ISD.)

Six

ALDINE ISD

Becoming independent did not deliver as many benefits as Aldine residents and parents had initially hoped for the school district. Small farms and family residences formed the majority of AISD's tax base. These properties did not bring in much revenue. With no large-scale industry to tax, AISD had to supplement its budget with state and federal aid.

The district experienced several enrollment surges over its first quarter century and struggled to finance new schools and expansions. In addition, fires at a high school and an elementary campus set finances back further. An anti-tax school board faction in the late 1950s almost bankrupted the district with poor fiscal policy.

In the early 1960s, dynamic new leadership emerged with an eye toward the future. AISD sought to ease homeowners' tax burdens by encouraging industries to locate within the district. The opening of Houston Intercontinental Airport in 1969 helped this effort.

AISD became one of the state's fastest-growing districts between 1960 and 1980. Enrollment steadily climbed, and new schools opened yearly. The district embraced new teaching methods and expanded its curriculum at every level.

AISD also desegregated its schools under court order during this time. A federal court first ordered AISD to open all its campuses to black students in 1965. The court strengthened that order in 1977. It mandated the district bus students from black neighborhoods to schools in white areas.

The court's desegregation orders ended in 2002 thanks to changing demographics. AISD had been roughly 75 percent white and 25 percent black over its first 50 years. That started to change in the mid-1980s. An influx of Hispanics altered the face of the district so that by the dawn of the 21st century, they made up the majority of AISD's enrollment, rendering ongoing desegregation suits moot.

AISD grabbed the spotlight in 2009 when it won the prestigious Broad Prize. The prize recognized the district's efforts to educate a diverse range of children, many of whom confronted poverty daily. The nationwide award culminated the district's long climb from a semirural backwater to an urban educational example for others. Today, AISD educates nearly 67,000 students at 83 campuses.

ALDINE HIGH I. AISD opened the first Aldine High School on May 14, 1948. The $175,000 building—named for the local community—sat north of the former Marrs High (renamed Aldine Junior High). Unfortunately, Aldine High I quickly became overcrowded and could not be further expanded. By 1954, it needed replacement but burned down before a larger school could take its place. (Courtesy of Aldine ISD Mendel Heritage Museum.)

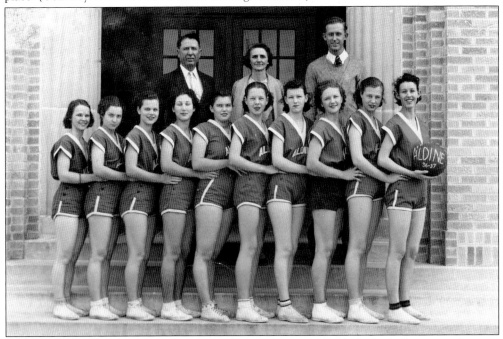

GIRLS' BASKETBALL, 1936–1937. Marrs High started boys' and girls' basketball teams in January 1935—the first varsity squads in district history. The teams initially played in the Harris County Interscholastic League. The boys' team moved to University Interscholastic League (UIL) competition by the 1940s, while the girls' team disbanded. A girls' UIL team briefly saw action in the 1950s but disappeared again until the mid-1970s. (Courtesy of Aldine ISD Mendel Heritage Museum.)

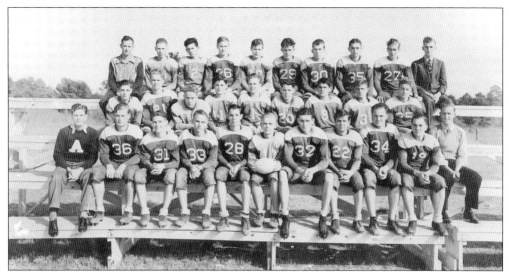

FOOTBALL TEAM, 1937. Marrs High fielded its first UIL football team in 1937 after two years of playing an outlaw schedule. Dubbed the Aldine Mustangs after the local town, the team lost its first varsity UIL game 44-0 at Texas City. The Mustangs' initial seasons proved tough, but the team improved by the 1940s, winning several district titles. (Courtesy of Aldine ISD Mendel Heritage Museum.)

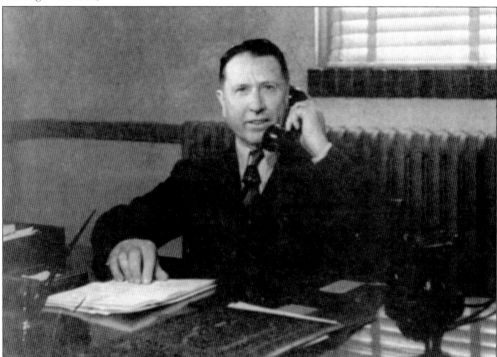

SUPT. SAMUEL FENNER. Fenner was working for the Houston Chamber of Commerce and as a county agricultural agent when CSD 29 hired him in 1932 as its first superintendent of schools. Fenner oversaw the construction of the Marrs School, handled district business, hired faculty, and taught high school biology. He served as superintendent until 1941, dismissed after a dispute with the school board. (Courtesy of Aldine ISD Mendel Heritage Museum.)

EARLY SUPERINTENDENTS 2–4. John Barden (above left) followed Samuel Fenner as superintendent from 1941 to 1944 and guided AISD through World War II. L.C. Courtney (above right) led AISD from 1944 to 1954. AISD's enrollment surged during Courtney's tenure. He got the district to build the first schools outside the centralized Aldine-Westfield campus, starting with Orange Grove Elementary in 1947. He also oversaw the construction of the first Aldine High School in 1948 and the current Carver High School in 1954. Johnnie Elsik (left) became the district's first assistant superintendent in 1951 before holding the top job from 1954 to 1957. As assistant superintendent, Elsik supervised a district-wide property reevaluation, the results of which prompted an anti-tax association to claim control of the school board, leading to Elsik's ultimate demise as superintendent in 1957. (All, courtesy of Aldine ISD Mendel Heritage Museum.)

EARLY SUPERINTENDENTS 5–7. Dr. Paul Hensarling (above left) was the first AISD superintendent since Fenner to come from outside the district, serving from 1957 to 1958. He left for Texas A&M University after a year due to school board interference with his job. W.W. Thorne (above right) took over from Hensarling in 1958 and led AISD through its most difficult period. Thorne's idea to sell time warrants saved the district from insolvency in 1959. Thorne left AISD in sound financial shape in 1973 to start North Harris County College. Thorne Stadium was named for him. M.O. Campbell (right) served as AISD's seventh superintendent from 1973 to 1986. Campbell started a "pay-as-you-go" policy that kept the district from incurring debt. AISD named the Campbell Center for him. (All, courtesy of Aldine ISD Mendel Heritage Museum.)

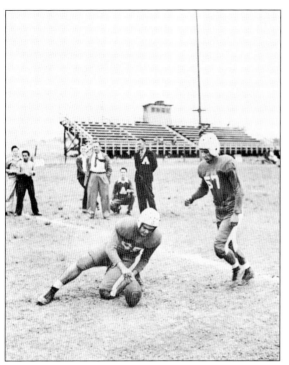

DADS' CLUB STADIUM, 1946. In 1938, fathers of the Mustang football players formed a booster organization called the Dads' Club. The club donated material and labor to build football grandstands for 2,500 fans, a concession stand, and a ticket booth. AISD installed lights to allow for night games. The stadium debuted on October 14, 1938, when the Mustangs played the Webster Wildcats. An estimated 2,000 spectators attended a dedication ceremony and exhibition game pitting the Mustang varsity team against an alumni squad. The stadium never received an official name. People just called it Dads' Club Stadium. Vocational agriculture students built the stadium's ticket booth (pictured below). The wooden grandstands and ticket booth are long gone, but Aldine Middle School still uses the field for football games. (Both, courtesy of Aldine ISD Mendel Heritage Museum.)

THE CARVER SCHOOL AND FACULTY. AISD annexed part of the White Oak District (CSD 26) in 1937. CSD 26 included a swath of Acres Homes, a majority black community. CSD 26 established the segregated White Oak Colored School there in 1915. By 1941, the schoolhouse had grown overcrowded, with some classes forced to meet at a nearby church. AISD opened a $20,000 replacement school that year with the same name. It housed AISD's first high school for blacks. The facility had four classrooms for grades 1–12, an auditorium that could hold two more classes, a home economics room, a library, and an administrative office. AISD renamed it after George Washington Carver in 1943. Below is a picture of the high school faculty in 1946. The high school moved to its own building in 1954. (Both, courtesy of Aldine ISD Mendel Heritage Museum.)

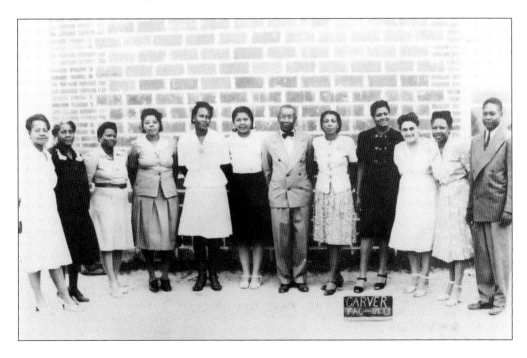

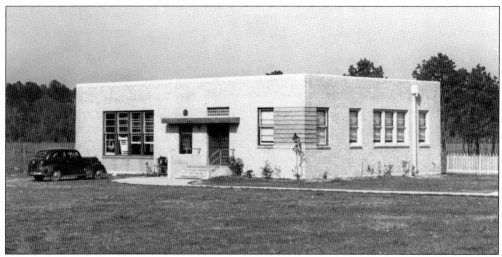

VOCATIONAL AGRICULTURE BUILDING. Marrs High underwent a $65,000 expansion in 1939. The school added a seven-classroom wing, along with detached structures for vocational agriculture and home economics. Marrs High's agricultural program became one of the county's best. The new building housed a classroom and shop where Future Farmers of America students learned to use farm machinery. (Courtesy of Aldine ISD Mendel Heritage Museum.)

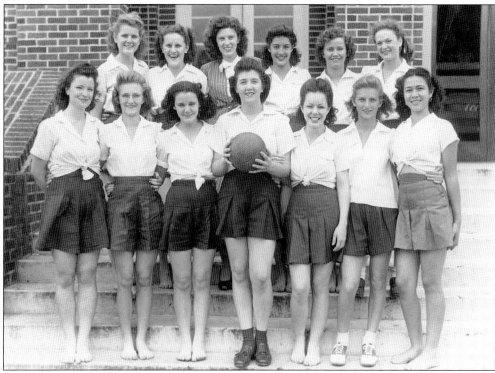

MARRS HIGH GIRLS' VOLLEYBALL, 1944–1945. Girls' high school sports were mostly intramural activities from the 1930s through the 1950s. They consisted mainly of competitions between physical education classes at the same school. Marrs High fielded a girls' volleyball team for several years that took part in county tournaments; however, the UIL did not sponsor many athletic competitions for females. (Courtesy of Aldine ISD Mendel Heritage Museum.)

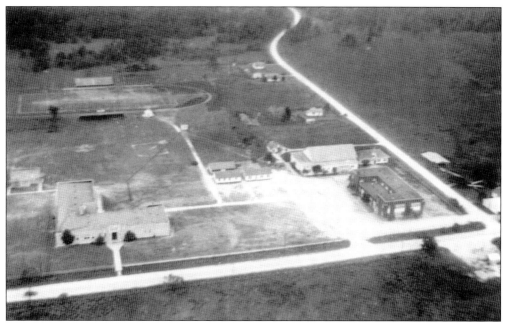

CENTRAL CAMPUS. The 22.5-acre site at Aldine-Westfield and Aldine-Bender Roads served as the centralized AISD school complex in the 1930s and 1940s. It started with a five-acre donation from Gus Oleson to CSD 29 in 1932. Subsequent purchases enlarged the campus over the years. The site is shown as it appeared in the mid-1940s. CSD 29 opened the Marrs School (later Aldine Elementary) in February 1933. The district moved the old two-room Aldine schoolhouse to the site in 1934. The newly created AISD constructed the gym in 1935. Marrs High School (now part of Aldine Middle School) followed in 1936 and underwent an expansion in 1939. Dad's Club Stadium debuted in 1938, with the agriculture and home economics buildings coming a year later. Finally, the cafeteria began serving lunches in 1943. (Both, courtesy of Aldine ISD Mendel Heritage Museum.)

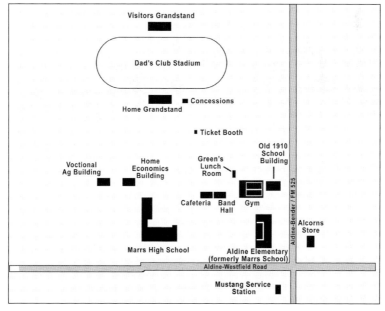

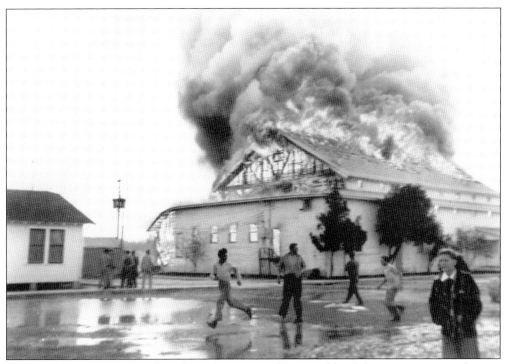

AISD GYM FIRE, 1948. A five-alarm fire, reportedly caused by defective wiring in a heater, destroyed the AISD gym just hours before a high school homecoming dance on November 19, 1948. No students were hurt in the blaze, although the football team and the band nearly lost their uniforms and instruments. AISD built the gym in 1935 out of recycled oil field lumber. (Courtesy of Aldine ISD Mendel Heritage Museum.)

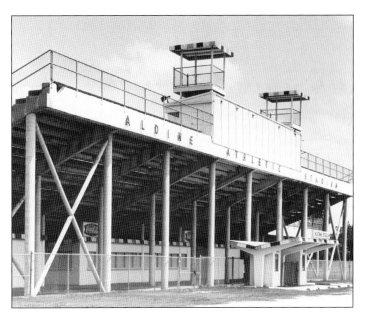

ALDINE ATHLETIC STADIUM, 1957. The $21,700, 6,200-capacity Aldine Athletic Stadium opened as the Aldine Mustangs' new home on the Airline campus's west side. The Mustangs beat San Antonio Northeast 41-6 in the stadium's first football game on October 4, 1957. Thorne Stadium replaced it in 1979. Now known as Smith Stadium, the site hosts track meets and district sub-varsity sporting events. (Courtesy of Aldine ISD Mendel Heritage Museum.)

VOTE 'NO'

On the Three-Quarter Million Dollar Bond Issue

On SATURDAY, DEC. 14

Taxes are High Enough. Vote NO on this Tax Raise.

The same old bunch is seeking your money. Let's get more for our present taxes instead of voting for higher taxes.

VOTE 'NO' on these Bonds

ON SATURDAY, DEC 14

AND BE SURE TO VOTE

SCHOOL BOND MATERIALS, 1957. Thanks to a 1950s enrollment surge, AISD needed more schools and classrooms to stay state accredited. However, a low-tax, spending-averse faction known as the Aldine Taxpayers Association had gained control of the school board by mid-decade. The group believed the district was wasting money on frivolous things. By cutting unnecessary spending, the association and its allied school board members contended they could lower tax rates to give district homeowners a break. However, even with a pro-economy platform, school trustees realized something had to be done to relieve overcrowding. Otherwise, AISD could face state-imposed penalties and lose funding. So, the association-dominated school board proposed a quite modest for that time $750,000 bond issue in 1957. The association's leadership broke with its school board allies and opposed the bond. Voters bought the message in this flyer and rejected the bond issue by a more than 2-1 margin. Two new association-backed trustees joined the board in 1958 and further tightened spending to cut back on maintenance. Aldine's overcrowded schools deteriorated and learning suffered. (Courtesy of Aldine ISD Mendel Heritage Museum.)

MEMBERSHIP CARD

Nº 170

Aldine Taxpayers Association

This Certifies That Member

MRS. H. L. NICOL

Has Paid Dues Through Dec. 31, 1959

Dues $1.00 Per Year

Joe H. Holman

Treasurer

ALDINE TAXPAYER ASSOCIATION ID. In the late 1940s, several large landowners started the Aldine Taxpayers Association. The association initially had a benevolent interest in the district and its students. However, in the mid-1950s, it gained control of the AISD school board. The association's austere spending and tax policies caused revenue shortfalls that meant AISD could not fund operations or maintain its schools by 1959. (Courtesy of Aldine ISD Mendel Heritage Museum.)

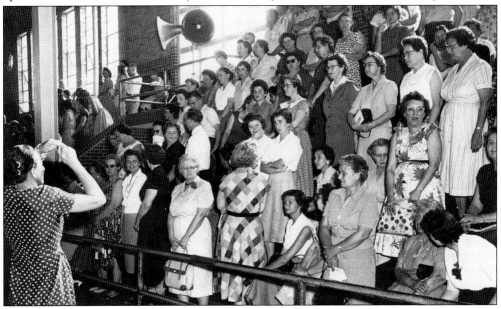

WALKOUT. AISD canceled classes on April 16–17, 1959, after teachers walked off the job. The district could not generate enough revenue to meet payroll. AISD sold time warrants (similar to bonds) to raise funds, which temporarily fixed the problem. However, the situation repeated two weeks later. This time, bankers froze the district's account after trustees fought over who could sign paychecks. (Courtesy of Houston Metropolitan Research Center, Houston Post Photograph Collection.)

ALDINE ISD IN COURT. AISD school board trustees Robert Whitmarsh, Harry Ammons, and Carl Tautenhahn listen to court testimony in July 1959. Aldine parents had petitioned the court to remove the three trustees—members of the Aldine Taxpayers Association—from office because their actions nearly caused the district to become insolvent earlier in the year. The court ultimately agreed with the petitioners. (Courtesy of Houston Metropolitan Research Center, Houston Post Photography Collection.)

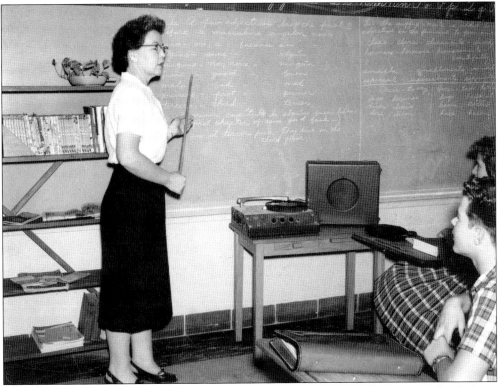

MOVING FORWARD. After the district emerged from its financial crisis in the summer of 1959, Supt. W.W. Thorne acted quickly to bolster AISD's academic program and reputation. Thorne first raised AISD's high school graduation requirements from 18 credits to 22. Schools began offering additional science, math, and foreign language courses. New business and vocational courses also joined the curriculum. (Courtesy of Aldine ISD Mendel Heritage Museum.)

GUS OLESON. Known simply as "Pop" to thousands of Aldine kids, Gus Oleson, born in 1869, came to America from Sweden in 1881. After working as a coal miner in Iowa, he arrived in Aldine in 1895 and took up dairying and produce farming, raising tomatoes, potatoes, and peppers. Oleson sometimes struggled with English. His son later recalled that at the downtown farmers market, Gus would just answer "$7 a bushel" to every inquiry. At age 63, he donated five acres of land to CSD 29 in 1932 for a new school. All Oleson asked in return was a job as a school custodian, which he held until his retirement in 1951. Even after retirement, Pop would visit the school just to make sure everything was going okay. Pop passed away in 1957. Four years later, AISD dedicated a new school—Gus Oleson Elementary—showing the esteem the district and community held for Pop. (Courtesy of Aldine ISD Mendel Heritage Museum.)

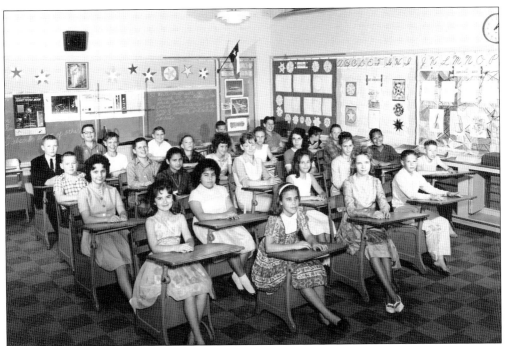

ALDINE SCHOOLS IN THE 1960S. Cheerful Mendel Elementary students cannot decide if they should listen to the teacher or smile for the photographer in a picture from the 1963–1964 school year. A close look shows all the girls are wearing dresses. Girls could not wear pants at any level until the 1970s. (Courtesy of Aldine ISD Mendel Heritage Museum.)

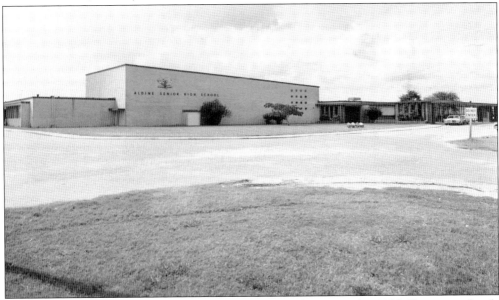

ALDINE HIGH SCHOOL II. The modern Aldine High opened in September 1956. Shown is its facade as it appeared before a 1973 expansion. The auditorium is visible at center with that era's band hall to the left. Neither can be seen from the outside today as new classroom wings obscure them. The school entrance of the time is on the right. It, too, is now hidden behind later expansions. (Courtesy of Aldine ISD Mendel Heritage Museum.)

HAMBRICK JUNIOR HIGH SCHOOL, 1961. Hambrick's 1961 opening relieved overcrowding at Aldine Junior and Aldine Senior schools. Because of packed high school classrooms, AISD reassigned ninth graders to the district's junior highs, where they would stay until nearby MacArthur High's 1966 debut. Future AISD superintendent M.O. Campbell was Hambrick's first principal. Hambrick is on Aldine Mail Route near Gus Oleson Elementary. (Courtesy of Aldine ISD Mendel Heritage Museum.)

HAMBRICK JUNIOR HIGH DEDICATION, 1962. Named in honor of former CSD 29 trustee Mattie Hambrick, AISD dedicated the new school on March 8, 1962. From left to right are AISD superintendent W.W. Thorne, Mattie Hambrick, and Hambrick principal M.O. Campbell. (Courtesy of Aldine ISD Mendel Heritage Museum.)

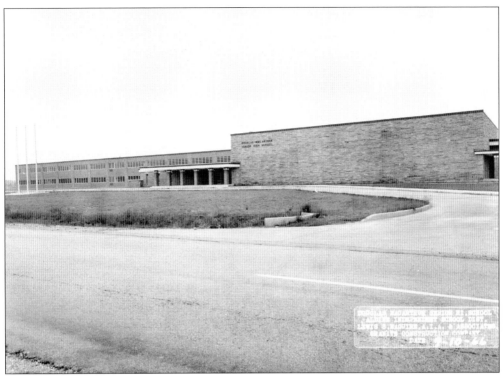

MacArthur High School, 1966. In 1964, the Aldine school board approved plans for a new $2.5 million high school named after the late American military hero Gen. Douglas A. MacArthur. Designed by architect Romney Dansby, the school opened in 1966 with Gerald V. Cook as the first principal. (Courtesy of Aldine ISD Mendel Heritage Museum.)

State Baseball Champs, 1970. The Aldine Mustangs captured the Class 4A baseball championship in the spring of 1970—the first state title for an AISD sports team. Aldine defeated the powerhouse Bellaire Cardinals 4-0 in a wild combined no-hitter by pitchers Glenn Bryant and Stan Shockley. Center fielder Phillip Terrell collected three hits for the Mustangs, who finished with a 25-5 record. (Courtesy of Aldine ISD Mendel Heritage Museum.)

EISENHOWER HIGH SCHOOL. Opened in 1972, the campus was named for Dwight D. Eisenhower, supreme commander of the Allied Expeditionary Force in Europe during World War II and America's 34th president. Eisenhower was Aldine ISD's first desegregated high school. When it opened, it was a junior-senior high school, educating students in grades 7–12. (Courtesy of Aldine ISD Mendel Heritage Museum.)

VISIT BY JULIE NIXON EISENHOWER. Julie Nixon Eisenhower, the daughter of Pres. Richard M. Nixon and the wife of David Eisenhower (grandson of former president Dwight D. Eisenhower), was the guest speaker at the dedication of the new Eisenhower Junior-Senior High School in 1972. (Courtesy of Aldine ISD Mendel Heritage Museum.)

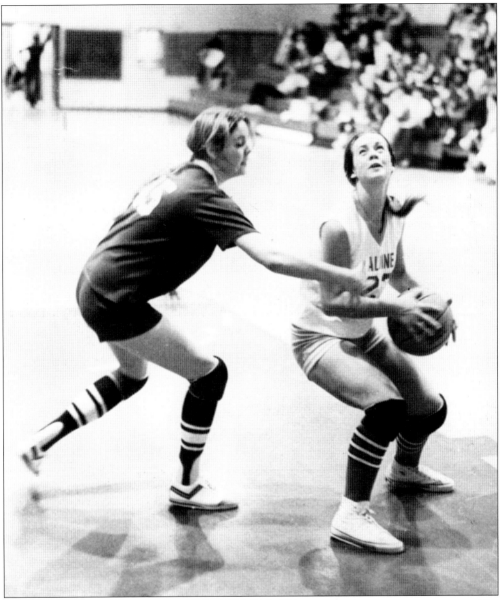

ALDINE HIGH GIRLS' BASKETBALL, 1975–1976. Title IX laws opened up many new opportunities for young women. The measure, passed by Congress in 1972, ensured female amateur athletes and school vocational programs received the same funding as those for males. AISD acted quickly to comply. By the mid-1970s, the district had girls' varsity and sub-varsity volleyball and basketball teams competing in UIL play. Girls' track, swimming, and softball squads followed over the next few years. Here, Aldine's Tricia McCullough (right) looks to score a basket against a MacArthur opponent in a 1976 contest. Title IX also allowed girls to enroll in traditionally male vocational classes like Future Farmers of America, drafting, and radio-television. The opportunities went both ways. Several boys signed up for classes usually taken by girls, such as home economics, foods lab, cosmetology, and health occupations. (Courtesy of Aldine ISD Mendel Heritage Museum.)

ALDINE STADIUM CAVE-IN, 1977. Five Aldine High School trombone players were rushed to a local hospital after a section of concrete stands gave way before a football game against Carver High on September 8, 1977. The band members were filing into their assigned seats in Aldine Athletic Stadium when the collapse occurred. They fell 25 feet to the ground. The crumbled section sat four rows from the stadium's top. Fortunately, no one was standing under it during the cave-in. The five students suffered minor injuries and recovered. Aldine Athletic Stadium opened in 1957 and underwent an expansion in 1965. AISD never rescheduled the Aldine/Carver game. The next week, the Mustangs held their "homecoming" game at Klein. AISD's football teams played their remaining 1977 home games at Cy-Fair's Bobcat Stadium. The incident accelerated AISD's plan for a new stadium, which voters had approved in a 1973 bond package. Aldine Athletic Stadium reopened in 1978 before Thorne Stadium replaced it in 1979. (Courtesy of Houston Metropolitan Research Center, Houston Post Photograph Collection.)

STATE GOLF CHAMPS, 1974. The Eisenhower Eagle boys' golf team clubbed the competition to claim the state Class AA championship in only the school's second year of existence. Eisenhower (652) finished 21 shots ahead of second-place Tulia (673) in the two-round tournament. The Eagles' Craig Barton also won the individual title with a combined score of 152. (Courtesy of Aldine ISD Mendel Heritage Museum.)

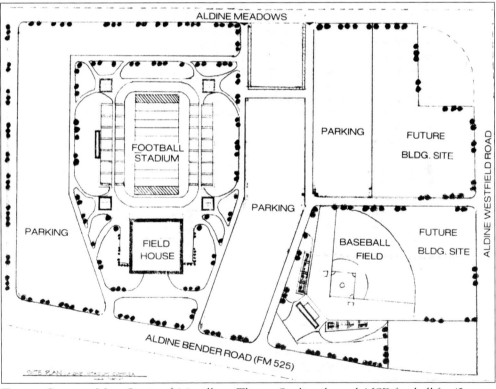

THORNE STADIUM MAP. Costing $4.4 million, Thorne Stadium hosted AISD football for 42 years. Houston Lee beat MacArthur 31-13 in Thorne's first game in September 1979, while Nimitz shut out Aldine 51-0 in November 2021 for its final contest. The district is replacing Thorne Stadium with a new $50 million facility to open in 2024. AISD teams will call Spring ISD's George Stadium home in 2022 and 2023. (Courtesy of Aldine ISD Mendel Heritage Museum.)

JAPANESE SUPERINTENDENT VISIT, 1983. Masao Iuchi, who led schools in Chiba, Japan, talked with AISD superintendent M.O. Campbell in August 1983. In Houston, as part of the sister cities program, Iuchi and Campbell discussed the differences between Japanese and Texas education systems. Japanese ninth grader Tomomasa Monden and AISD seventh grader Lara Stevens also took part in the visit. Iuchi and Monden talked about the incredible pressure in Japanese schools. They said parents were heavily involved in their children's education compared to those in Aldine. They also contrasted how Aldine schools had an advantage of more counselors and more electives than their Japanese counterparts did. (Both, courtesy of Houston Metropolitan Research Center, Houston Post Photograph Collection.)

ALDINE'S 50TH ANNIVERSARY, 1985. All of AISD turned out for a Thorne Stadium gala on May 4, 1985, to celebrate the district's 50th anniversary. After much research and rehearsal, students reenacted Aldine's and AISD's history. Former educators and administrators returned to recount tales of AISD's early days and how it overcame numerous challenges to reach this important milestone. (Courtesy of Aldine ISD Mendel Heritage Museum.)

STATE FOOTBALL CHAMPIONS, 1990. Quarterback Eric Gray rushed for 236 yards and two touchdowns to lead top-rated Aldine past number two Arlington Lamar 27-10 in the Class 5A Regular Division championship at the Astrodome. The win snared the Mustangs the state title they had hungered for since dropping the 1989 final. It also earned them ESPN's mythical national high school football championship. (Courtesy of Mark McKee.)

GUN SAFETY TRAINING, 1988. With rising crime plaguing the area, the Houston Police Department opened a storefront center in Greenspoint Mall in the mid-1980s. Many Aldine families were no doubt also considering the purchase of a firearm or handgun for protection by January 1988. That is when AISD officials arranged for a gun safety training presentation at Aldine High School for parents and students. In the above photograph, Harold Brian, Texas Parks and Wildlife Department's area chief instructor, holds up a typical handgun in the school library. He lets an attendee take an up-close look at a pistol in the picture below. (Both, courtesy of Houston Metropolitan Research Center, Houston Post Photograph Collection.)

Seven

IN AND AROUND ALDINE

Aldine has few landmarks or attractions, and even as the home of one of America's largest airports, it lacks tourist draws to entice people to stick around after getting off the plane. Despite this, Aldine has had several memorable places that locals fondly recall. We will touch on a few here.

Greenspoint Mall was perhaps Aldine's best-known destination. The mall opened in August 1976 with more than 100 stores, and during its height in the early 1980s, it boasted six national or regional anchor chains. The mall also served as a source of jobs and a hangout for Aldine teens. A 1991 kidnapping incident soured the mall's reputation, and shoppers took their business elsewhere. By the early 2000s, Greenspoint was just a shell of its former self.

The I-45 Drive-In Theater along the North Freeway at West Road showed its inaugural movie in July 1982. Deauville and Greenspoint Mall were among the first local indoor cinemas. Those who enjoyed the stage could view plays at the Greenspoint Inn Dinner Theater.

Aldine residents had several other pleasure spots starting in the late 1940s and early 1950s. These included the H&H Guest Ranch, Circle 8 Rodeo, and the North Houston Speedway.

Athletes of all ages had options, too. Dow Park No. 1 offered youth baseball and football. Adults could take their swings in leagues at Softball City. For those who preferred parks, Aldine offered several, the largest being Keith-Wiess.

Besides Greens and Halls Bayous, Aldine has no distinctive natural features. It does have several man-made ones. The earliest were two gasoline tank farms along what is now the North Freeway. Humble Oil opened a facility at Gulf Bank Road in 1947, while Sinclair Oil started one just south of Greens Road a year later. Radio station KLEE-AM (now KILT-AM) constructed a transmission tower on West Road in 1948 that many locals used as a sign they were approaching home.

Aldine's first skyscraper—the Gibraltar Tower on Greens Road—welcomed occupants in 1980. The area's tallest building, the 23-story Four Greenspoint Plaza on Northchase Drive, followed in 1983.

LOG CABIN INN RESTAURANT. For 50 years, the Log Cabin Inn was a north Harris County legend, renowned for its fried chicken. Founded by Beulah Futch Ward in 1938, the restaurant was originally located closer to Humble. Beulah's son A.Z. and his wife, Relda Ward, took over in 1946 and moved it to Lee Road and US 59 in 1951. The Wards built the restaurant's exterior to resemble a log cabin. Waitresses wore matching uniforms, and the dining room had distinctive red and green tablecloths. Log Cabin Inn served food "family style," bringing out food on platters and in large bowls, as if diners were sitting at the family dinner table. An expansion of US 59 in 1990 forced the restaurant to close. (Both, courtesy of Aldine ISD Mendel Heritage Museum.)

A La Carte

T-BONE .	1.75
LOIN STRIP STEAK, Cut From Aged Beef .	2.00
SIRLOIN .	2.00
FRIED CHICKEN . SKILLET FRIED	1.25
ALL WHITE or ALL DARK MEAT	1.50
LIVERS or GIZZARDS	1.25
LIVERS and GIZZARDS	1.25

French Fried Potatoes, Cream Gravy,

Hot Biscuits

FOR CHILDREN UNDER 12 ONLY

HALF CHICKEN DINNER75

A Devoted Wife Who Does the Dishes
Should Be Granted These Three Wishes
A Grateful Mate, A Well Kissed Cheek
And a Restaurant Dinner Every Week

Let Us Prepare and Serve Your Next Banquet or Party

LOG CABIN INN MENU. The Log Cabin Inn had a simple, one-page menu. No frills here. For most who passed through the doors, a menu simply was not needed. Visitors already knew what they wanted. Years later, a frequent patron would recall on social media, "I'm not sure if they served any other meat, but they cooked up the world's best fried chicken. The crust was light and golden, and when you bit into a piece, you didn't get a mouth full of grease like you do at some places today. Out back, they had a large garden where they grew much of their vegetables. There were rows of corn, beans, tomatoes, and cucumbers, which the restaurant would cook up to serve its customers. I remember the sign over the door, 'If you leave here hungry, it's your own darn fault!' I never did." (Courtesy of Dr. Robert Meaux.)

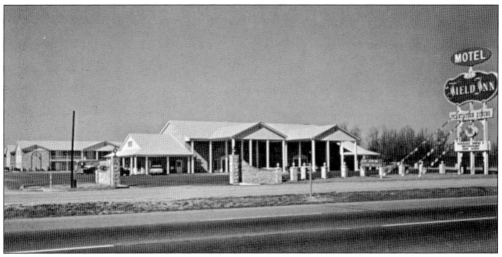

FIELD INN MOTEL, 1966. Aldine's first large motel was the Field Inn at 11211 North Freeway. It also offered long-term housing, making it one of Aldine's first apartment complexes, too. Field Inn opened in 1966. The site featured a restaurant, private club, bus service, and banquet facilities. Motel rooms initially cost $8 a night while apartments rented for $130 a month. (Courtesy of Humble Museum.)

CROWLEY PARK. Crowley Park debuted in 1977 on Lauder Road. It features 30 acres of woodlands, ball fields, and open areas for visitors to relax, picnic, play sports, and exercise. The park is named for William E. "Bill" Crowley, who was a general superintendent of Harris County roads and bridges for many years. (Courtesy of Katie Meaux.)

SCHLOBOHM FAMILY CEMETERY. West of Crowley Park, the Schlobohm family cemetery started in 1873 with the burial of Fredericka Schlobohm, daughter of early area settlers Johann (1807–1882) and Caroline Schlobohm (1823–1886). Johann and Caroline's descendants still maintain the private cemetery, which has a Texas historical marker. (Courtesy of Dr. Robert Meaux.)

PATTERSON'S MUSTANG SERVICE STATION. Sitting across from the Aldine-Westfield school site, the Mustang Service Station was owned and operated by Jimmy Patterson, who graduated from Marrs High in 1935. He was a big supporter of Marrs/Aldine High. Patterson named his Texaco station after the school mascot, ran advertisements in the campus newspaper and yearbook, and donated time and transportation to extracurricular activities. (Courtesy of Aldine ISD Mendel Heritage Museum.)

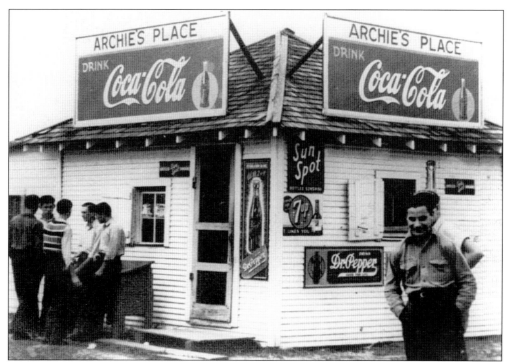

ARCHIE'S PLACE. AISD lacked a campus cafeteria in the 1930s, so students could go off school grounds to eat lunch. Archie's Place and Alcorn's were two nearby food stands that competed for kids' lunch money. Both served sandwiches, hamburgers, hot dogs, chips, cold drinks, and candies. Business declined once AISD opened a cafeteria in 1943. (Courtesy of Aldine ISD Mendel Heritage Museum.)

ALDINE BRANCH LIBRARY. The Aldine area's rapid growth left a gap in learning resources for children and adults by the early 1970s. Harris County responded by opening the Aldine Branch Library on Airline Drive in April 1976. The library originally held 12,000 books, and eager patrons borrowed more than 1,000 titles on opening day. (Courtesy of Harris County Public Library Archives.)

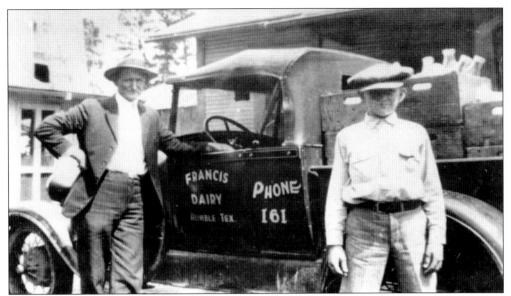

FRANCIS DAIRY. Thomas Barker Francis started the Francis Dairy with his brother-in-law Alec McDonald. The dairy was located off Carpenter Road in Humble but later moved to land that is now part of George Bush Intercontinental Airport. Francis served on the final CSD 29 board of trustees (1933–1935) and was president of AISD's first school board (1935–1938). Francis Elementary was named in his honor. (Courtesy of Humble Museum, Francis Family Collection.)

CHRISTIAN ROCK FESTIVAL. Many interesting activities take place across the Aldine area each year. Some of them include church- and family-oriented events such as this Christian rock festival, which was held in May 1971 in an open field across the street from the Lane Center. (Courtesy of Houston Metropolitan Research Center, Houston Post Photograph Collection.)

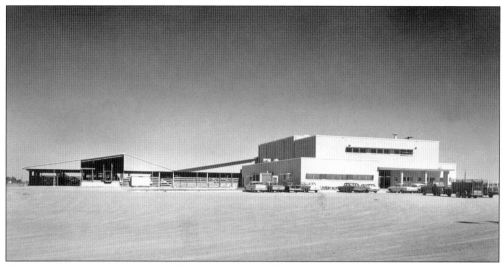

CATTLE AUCTION, 1962. North Houston Auction Co. opened the nation's then-largest cattle auction barn on Rankin Road, near the Armour processing and packing plant, in June 1962. The venture was intended to make north Houston an agricultural hub for Harris County. A hog was the first animal auctioned on opening day, followed by horses, and finally, cattle. (Courtesy of Humble Museum.)

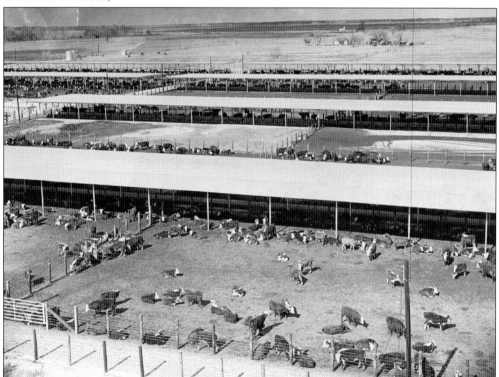

BIG FEEDLOT, 1961. United Industries' cattle feedlot on Rankin Road west of US 75 could handle 5,000 livestock at a time. The feedlot provided cattle for the nearby Armour meat processing and packing plant. A barn and auction house were located on the same site. (Courtesy of Houston Metropolitan Research Center, Houston Post Photograph Collection.)

HOUSTON NATIONAL CEMETERY. The Houston Veterans Administration Cemetery was dedicated on December 7, 1965. It was the only government cemetery constructed in the United States during the 1960s. It became a national cemetery in 1973 after the passage of the National Cemetery Act. The cemetery encompasses 419.2 acres, only about half of which is developed. The site features an impressive hemicycle, a fallen soldier statue, and a 75-foot-tall, 305-bell carillon. The Americana carillon was dedicated on Memorial Day in 1970. Pfc. Jeff F. Evans was the cemetery's first burial. Evans fought with the Army in the Pacific during World War II, earning many service awards. He died at age 41 on November 6, 1965, and lies in Section C, Site 1. The cemetery has had more than 111,000 interments as of 2021. (Both, courtesy of Katie Meaux.)

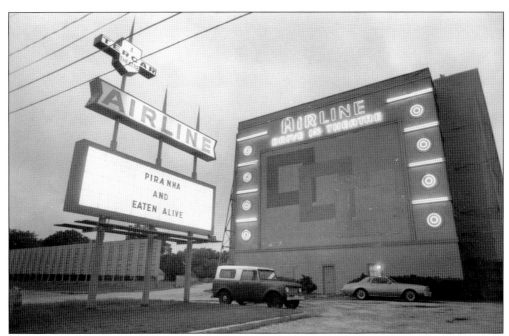

AIRLINE DRIVE-IN THEATRE. The Airline Drive-in opened in June 1950 with space for 600 cars and a children's playground in front of the giant movie screen. A centrally located snack bar provided car service. As Aldine lacked entertainment venues in the 1950s, residents (especially teens) often flocked into Houston to the Airline and nearby North Shepherd drive-in theaters for an evening of fun. Airline's first showing was *Canadian Pacific* with Randolph Scott and Jane Wyatt. Willie Nelson performed a concert here in September 1978. The drive-in closed and the land was redeveloped by 1981. (Both, courtesy of Houston Metropolitan Research Center, Houston Post Photograph Collection.)

MORALES CEMETERY. Felix and Angela Morales established a cemetery on Buschong Street at Luthe Road in 1940. The Morales Cemetery was special because it was one of the first in Houston to allow families to decorate their loved ones' graves in the traditional Mexican and Latin American manner. (Courtesy of Katie Meaux.)

NORTH HARRIS COUNTY COLLEGE. North Harris County College, a two-year community college, opened its first permanent campus in 1976 near FM 1960 and Aldine-Westfield Road. The college held its inaugural classes at Aldine High School in 1973. Now called Lone Star College–North Harris, the original campus is one of 20 facilities the college system operates. (Courtesy of Aldine ISD Mendel Heritage Museum.)

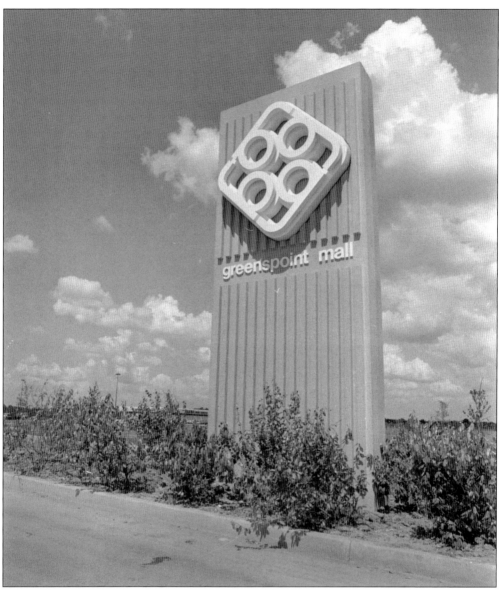

GREENSPOINT MALL. Located at the northeast corner of I-45 and North Belt, Greenspoint Mall is a 140-acre shopping center. Today, the mall is nearly empty and defunct. However, at its beginning, it hosted three department stores, two large specialty stores, and 120 smaller shops. Federated Department Stores developed the mall, originally named Greensgate, starting in November 1974. Renamed Greenspoint, the mall opened on August 5, 1976. It was the first stage in a planned 365-acre residential, shopping, and office complex. The 800,000-square-foot, enclosed, climate-controlled design of Greenspoint Mall made intensive use of landscaping and the sensitive utilization of aesthetics. Shops extended north and south along a brick-paved avenue of full-grown ficus nitida trees. Shoppers enjoyed walking the mall in natural sunlight thanks to the overhead skylights. Designers used natural wood extensively throughout the mall, blended with textured stucco of soft beiges and warm browns. Prominently featured fountains and sculptures added to the mall's atmosphere. (Courtesy of Houston Metropolitan Research Center, Houston Post Photograph Collection.)

GREENSPOINT MALL UNDER CONSTRUCTION. Foley's and Sears were the mall's original anchor stores, along with large specialty stores Palais Royal and Battlestein's. Greenspoint represented Foley's seventh Houston-area store. Sears was a two-story store with a 20-car automotive center. It closed in 2010. Foley's became a Macy's in 2006 and closed in 2017. (Courtesy of Houston Metropolitan Research Center, Houston Post Photograph Collection.)

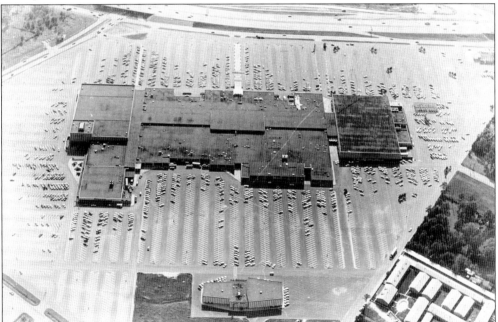

GREENSPOINT MALL, 1976. This early aerial photograph of the Greenspoint Mall site shows the shopping center's original configuration. Sears was on the left and Foley's on the right. The mall opened for business in August 1976. (Courtesy of Aldine ISD Mendel Heritage Museum.)

GREENSPOINT MALL, CENTRE COURT. The central court of the mall featured a water wall where 1,000 gallons of water a minute cascaded from an upper-level promenade to a pool below. Pumped up to a height of 13 feet, the water dispersed through outlets at the promenade level to create a sheet of water that resembled a wall. Steps lined the pool edges, inviting shoppers to sit and enjoy the view. Centre Court's outer boundaries featured rows of planter mountains where thousands of plants and flowers, nourished by the sun through overhead skylights, climbed to a height of 20 feet. The Centre Court Café, located atop the water wall, featured tables with yellow umbrellas and a light menu of soups, salads, quiches, and sandwiches. (Courtesy of Houston Metropolitan Research Center, Houston Post Photograph Collection.)

GREENSPOINT MALL, CHILDREN'S COURT. No kid likes shopping, but a trip to the mall became a little more bearable thanks to Greenspoint's playground in the Children's Court. The playground gave kids a chance to run around while moms and dads took a welcomed break. (Courtesy of Houston Metropolitan Research Center, Houston Post Photograph Collection.)

SHOPPERS AT GREENSPOINT MALL. The mall opened on August 5, 1976, drawing people from across north Harris County and beyond. Shoppers could choose from 120 retailers and shops. Greenspoint merchants enjoyed many profitable days in the mall's early years. The mall averaged 30,000 visitors per day and became one of the nation's top shopping centers based on sales per square foot. (Courtesy of Houston Metropolitan Research Center, Houston Post Photograph Collection.)

GREENSPOINT MALL, AVENUE OF SHOPS. Early advertising taglines for Greenspoint Mall touted the shopping center's desire to "bring the outdoors in." The mall's design was unique due to its extensive use of a large variety of plants. The mall contained one of the largest collections of tropical plants and trees in Houston. Small leaf rubber trees dominated the mall's interior avenue of shops. The main corridors were lined by these 25-foot tall trees, making use of the natural sunlight streaming through overhead skylights. *Codiaeum variegatum* colorfully defined court areas, while areca butterfly palm promoted the illusion of height in smaller court areas. Numerous varieties of plants enhanced the mall's central court, creating a relaxing tropical rainforest atmosphere. Cornelius Nurseries of Houston designed and arranged the mall's interior landscaping. (Courtesy of Houston Metropolitan Research Center, Houston Post Photograph Collection.)

GREENSPOINT MALL, FOOD COURT. The Patio—a central food court—featured 14 eateries with a variety of choices. These included Baskin Robbins, Taco Spot, Famous Ramos Hot Dogs, Pretzel Shoppe, Steve's Sandwich Shop, Tiffany Bakery, Polar Bar, Hamburger Hamlet, Fortune Cookie, The Creperie, and a pizzeria. The mall also housed an El Chico and a Piccadilly Cafeteria. (Courtesy of Houston Metropolitan Research Center, Houston Post Photograph Collection.)

GREENSPOINT MALL, SPECIALTY STORES. Many specialty stores filled the mall corridors, including E/J's Model Shop, Baldwin-Lively Piano & Organ, B. Dalton Bookseller, Funway Freeway, Pickwick Music, Alberto's Clocks & Watch Shop, Haus Edelweiss, Wicks & Sticks, Morrow's Nut House, Houston Trunk Factory, and Playhouse Toys. (Courtesy of Houston Metropolitan Research Center, Houston Post Photograph Collection.)

GREENSPOINT MALL, FOLEY'S. The Greenspoint Mall location was Foley's seventh Houston-area store. The two-story outlet anchored the mall's north end and occupied 207,000 square feet. The soaring Escalator Pavilion near Foley's mall entrance was its distinguishing feature. The pavilion incorporated chestnut wood, mirrors, and dramatic lighting. Skylight canopies at the outside entrances welcomed customers in a bright, unique way. Foley's Greenspoint location exceeded all of the chain's sales expectations in its first year. The only thing holding it back was the store's size; at 207,000 square feet, it was one of the smallest locations in the company. Foley's expanded the store by 100,000 square feet in 1980. Macy's bought Foley's in 2006 and continued to operate the Greenspoint location under the Macy's name. The store closed in early 2017, making it Greenspoint's first and last anchor store. (Houston Metropolitan Research Center, Houston Post Photograph Collection.)

GREENSPOINT MALL SCULPTURES. The Sculpture Court at the north junction between Foley's and the mall's Centre Court featured a life-size sculpture of children playing by Pat Foley, a Houston sculptor. The 2,000-pound bronze statue featured a young girl and boy in a swing that appeared as if it was suspended from an overhead space. (Courtesy of Houston Metropolitan Research Center, Houston Post Photograph Collection.)

GREENSPOINT MALL FOUNTAINS. In addition to the Centre Court water wall, Greenspoint Mall had two other fountains: one in front of Foley's (pictured here) and another in front of Montgomery Ward. The Montgomery Ward fountain made music. Falling water would fill a series of empty tubes, causing them to slowly dip and hit a hollow pipe, producing a bell-like musical tone. (Courtesy of Houston Metropolitan Research Center, Houston Post Photograph Collection.)

GREENSPOINT MALL, MONTGOMERY WARD. Greenspoint Mall began expanding in July 1977. As a new J.C. Penney store was nearing completion for a November grand opening, work started on a new two-level, 154,000-square-foot Montgomery Ward plus an additional 32,000 square feet of satellite shops. The Montgomery Ward opened in July 1978 in the mall's northeast corner. It was the company's eighth full-line store in the Greater Houston area. Built by Harvey Construction Co. of Houston, it included a 16-bay automotive service center, a beauty salon, and a restaurant. The store closed in early 2001 after the 128-year-old retailer went out of business. (Both, courtesy of Houston Metropolitan Research Center, Houston Post Photograph Collection.)

PANCHO CLAUS. Pancho Claus was a Mexican version of Santa Claus popular in Texas, and has been portrayed by Richard Reyes in north Houston since 1981. Children instantly recognized his distinctive red zoot suit and fedora. Reyes raises funds, distributed gifts, and ran programs to assist teenagers in detention to help them get their lives in order. (Courtesy of Houston Metropolitan Research Center, Houston Post Photograph Collection.)

STEAK & ALE IN ALDINE. Steak & Ale was a chain of steak restaurants founded in Texas, with 280 locations at its peak. With its dimly lit, Tudor-style dining rooms and salad bar, Steak & Ale was an ideal choice for those wanting an upscale dining experience at a low price. The North Freeway and Humble restaurants were popular with Aldiners. (Courtesy of Houston Metropolitan Research Center, Houston Post Photograph Collection.)

KEITH-WIESS PARK. The 500-acre site was the first major regional park in north Houston when the city acquired it in 1979. It was named for Olga Keith Wiess, a Houston philanthropist and widow of a founder of Humble Oil Co. (now ExxonMobil). The vast park includes spreads of old forest habitat, large ponds, and wetlands with several thousand trees, shrubs, and vegetation along Halls Bayou. Park development began in 1980. The city built baseball and soccer fields, tennis and basketball courts, and picnic shelters on 170 acres. The remaining 330 acres were left as open space for passive recreation. The park serves another valuable community purpose—acting as a giant stormwater reservoir during heavy rains. The park's detention ponds have been sculpted to blend in with the natural landscape. (Both, courtesy of Katie Meaux.)

I-45 DRIVE-IN. A six-screen drive-in theater that opened in July 1982, the I-45 Drive-In was a popular destination for families and dating teens. It was one of only five remaining drive-ins in the Houston area in the early 1980s. The drive-in used a system to broadcast the sound for the movie to car radios. There was no longer a need to roll down the windows and face an aerial assault from mosquitoes. *Star Trek II*, *The Thing*, and *Porky's* were the first movies shown on opening night. Confronted by growing light pollution and video rentals, the drive-in closed in March 1992, replaced by a shopping center. (Both, courtesy of Houston Metropolitan Research Center, Houston Post Photograph Collection.)

JESSE H. JONES PARK. This 312-acre park was named after the publisher of the *Houston Chronicle*. The area is traditionally considered the southwestern end of the Big Thicket area in East Texas. Opened to the public in 1982, natural beauty and history are combined in this unique setting along the banks of Spring Creek. (Courtesy of Dr. Robert Meaux.)

REDBUD HILL HOMESTEAD. Along with a diverse ecosystem, including ancient cypress bogs and wildflower meadows, Jesse H. Jones Park also contains a recreated 1830s Texas homestead, featuring a log cabin, kitchen garden, barn, and blacksmith and woodworking shops. There is also a recreated Akokisa-Ishak Indian village adjacent to the homestead. (Courtesy of Dr. Robert Meaux.)

HARDY TOLL ROAD, ONE-MILLIONTH CUSTOMER. On March 29, 1988, the Toll Road Authority recognized the one-millionth customer to use the Hardy Toll Road. Harris County judge Jon Lindsay presented Bo Tanner with a special resolution and a $25 roll of Susan B. Anthony dollar coins. (Courtesy of Houston Metropolitan Research Center, Houston Post Photograph Collection.)

HARDY TOLL ROAD BICYCLE CLASSIC. The opening of the first section of the Hardy Toll Road on September 19, 1987, featured a Confederate Air Force (now known as the Commemorative Air Force) flyby, a concert, a 54-mile bicycle race sponsored by the US Cycling Federation, and a leisurely sunset ride where the public could ride their bikes on the toll road before it opened to traffic. (Courtesy of Humble Museum.)

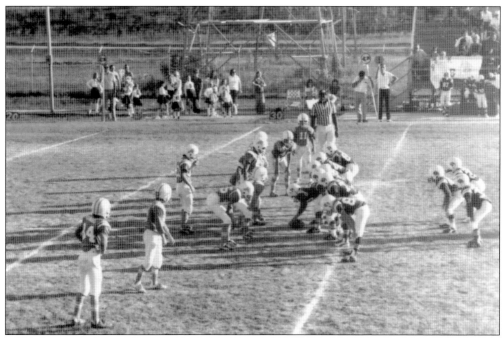

Dow No. 1 Park. Dow No. 1 Park is located at Hardy Road and North Belt. Charles Milby Dow (1892–1961), from a prominent Houston family, donated several parks across Houston and Harris County to combat juvenile delinquency. He purchased 15 neighborhood park sites of about 10 acres each. Dow No. 1 Park, consisting of nine acres, was donated to Harris County in January 1957. The park features two baseball fields, a football field, a playground, and picnic facilities. The football field, with its bleachers and press box, has been used extensively for local youth football games. (Both, courtesy of Dr. Robert Meaux.)

SOUND WAREHOUSE, GREENSPOINT. Sound Warehouse was a regional chain of record stores. Customers browsed rows of albums, cassettes, 8-tracks, and singles. Stores frequently hosted rock bands for interviews and autograph sessions. Sound Warehouse was one of the first video rental outlets. The Greenspoint Square store opened in June 1979 and moved to the Commons at Greenspoint in 1989. (Courtesy of Houston Metropolitan Research Center, Houston Post Photograph Collection.)

VIDEO ARCADES. Video arcades were the rage among youngsters and teens starting in the late 1970s. Bright lights and electronic sounds lured kids into parting with their quarters for a few minutes of adventure battling space aliens, dodging digital ghosts, or racing cars. Local arcades included Funway Freeway in Greenspoint Mall and the Electric Ice Cream Machine in Deauville Square. (Courtesy of Houston Metropolitan Research Center, Houston Post Photograph Collection.)

BROOKSIDE MEMORIAL PARK. This 290-acre perpetual care cemetery is located on the Eastex Freeway (Interstate 69/US 59) at Lauder Road. The Berry Plantation once occupied the site. Ira Brooks purchased the original 140-acre plantation cemetery in 1931 and gave it its present name. (Courtesy of Dr. Robert Meaux.)

CHAPEL OF THE CHIMES. Opened in 1944, this Gothic-style chapel is in the historic Berry Cemetery section of Brookside Memorial Park. The chapel features a vaulted ceiling and lancet-arched stained-glass windows. It was built of stone salvaged from the downtown Houston Presbyterian Church that had burned down. (Courtesy of Humble Museum.)

VOLUNTEER FIRE DEPARTMENTS (VFD). Homeowners organized two permanent fire brigades in 1942 to protect life and property in unincorporated south Aldine. Staffed by volunteers, Westfield VFD served the area from Hardy Road east to US 59. Little York VFD covered from Hardy Road west to US 75. Other VFDs soon followed, including Acres Homes (1948), Old Humble Road (1950), and Aldine (1960). (Courtesy of Aldine ISD Mendel Heritage Museum.)

PIZZA PARLORS, 1975. Valian's on South Main Street introduced Houstonians to pizza in the 1950s but was a long drive from Aldine. Pizza Inn on Dyna Drive opened in 1975 and was much closer. It quickly became a Friday night postgame hangout. Aldine High students also loved the nearby Square Pan, while Mr. Gatti's Pizza was a MacArthur High favorite. Showbiz, near Eisenhower High, catered to younger crowds. (Courtesy of the Humble Museum.)

Benningan's at Greenspoint. This Irish-themed bar and grill chain was popular for its two-for-one drinks and pub-inspired menu. The restaurant appealed equally to happy hour drinkers and family gatherings throughout the 1980s and 1990s. The Greenspoint location opened on the North Belt frontage road at Greenspoint Drive in 1979. Other similarly themed casual restaurants sprung up in and around the mall during this time. These included TGI Fridays, Birraporetti's, Maggie's, Houlihan's, and Mr. Dunderbak's. Greenspoint became a dining attraction in the 1980s. Among the other options were Willie G's, Smuggler's Inn, York Steak House, Brown Sugar's BBQ, Monterey House, Victoria Station, Luby's, Piccadilly Cafeteria, Marco's, El Chico, and El Torito. These restaurants offered not only a wide variety of dining choices but many employment opportunities for Aldine area youths. (Courtesy of Houston Metropolitan Research Center, Houston Post Photograph Collection.)

VICTORIA STATION AT GREENSPOINT. Opened in 1978 on Greens Road across from Greenspoint Mall, Victoria Station was a steakhouse with a theme loosely based on London's Victoria Station. The exterior consisted of railway boxcars and cabooses. Antique English railway artifacts were used as the inside decor. The main fare was prime rib, and the restaurant also served other steaks, barbecued beef ribs, and shrimp. (Courtesy of Humble Museum.)

BOBBY MCGEE'S CONGLOMERATION. Located in Deauville Square, this unique dining experience consisted of a restaurant with picturesque dining areas and a European discotheque. Two nine-foot bathtubs housed the salad bar, while an old Sears wood stove held the soups. Opened on December 21, 1974, waiters and staff dressed as Little Red Riding Hood, Groucho Marx, Indians, Superman, Pocahontas, Raggedy Ann, clowns, and other whimsical characters. (Courtesy of Humble Museum.)

SKATING RINKS. Roller skating has always been a fun, safe, and affordable outing for young people. North Houston has had many rinks over the years, each of which drew loyal crowds. The Rainbow Roller Rink was Aldine's first skating center, opening at Airline Drive and Aldine Mail Route in 1948. The rink later moved several times, ultimately ending up on Tidwell Road, but others later followed in and around Aldine. Buddy's Roller Rink opened near the Eastex Freeway in 1964. The Ranchtown, Aldine, Hidden Valley, Airline, and Northwest Skateworld rinks debuted between 1972 and 1974. Great Time Skate followed in 1981. (Above, courtesy of Houston Metropolitan Research Center, Houston Post Photograph Collection; below, courtesy of Humble Museum.)

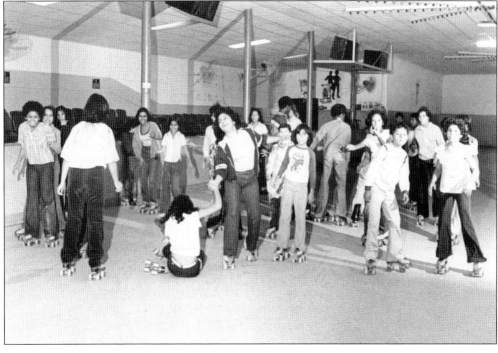

MANAGEMENT DISTRICTS. With widespread jurisdictions, it is often difficult for Harris County and the City of Houston to provide the services business owners expect. The Texas legislature responded to these concerns in 1991, allowing local nongovernmental entities to create special management districts that could tax businesses to supplement city and county services, including landscaping, maintenance, security, and marketing. Districts could only tax businesses, not residents. The Greenspoint Management District (now North Houston) was the first of these special districts, formed shortly after the law passed. The Airline District followed a year later, and the Aldine District (now East Aldine) in 2001. Each of these management districts has worked closely with local businesses to improve water/sewer infrastructure, transportation, environment, health, public safety, and the economy within their boundaries, and each has proven to be a valuable community resource. (Both, courtesy of Katie Meaux.)

NEIGHBORHOOD NEWSPAPERS, 1970S. The Houston area has had several citywide newspapers over the last 150 years. Only the *Chronicle* still publishes, as people have changed the way they get news. In the 1970s, several entrepreneurs ran weekly neighborhood papers in the Aldine area covering local news the big citywide dailies missed. These papers spotlighted schools, youth sports, and small businesses. At one time, Aldine residents could look forward to the latest editions of the *North Freeway Leader*, the *Northeast News*, the *Aldine Jet News*, the *Aldine Texan*, and the *News Messenger*. Unfortunately, newspapers are expensive to operate and depend on advertising revenue. Nearly all of these papers have gone extinct. Only the *Northeast News* remains in Aldine today. (Both, courtesy of Aldine ISD Mendel Heritage Museum.)

BIBLIOGRAPHY

Bond certification records, Harris County Archives. 1894–1949.

Commissioners court minutes, Harris County Clerk's Office. 1866–1954.

County school superintendent records, Harris County Department of Education.

HMRC image collections, Houston Metropolitan Research Center.

Houston Chronicle. 1901–2022.

Houston Post. 1880–1995.

Slotboom, Erik. *Houston Freeways: A Historical and Visual Journey*. Cincinnati, OH: C.J. Krehbiel, 2003.

Smith, Nina, ed. *A History of the Humble, Texas Area*. Humble, TX: James Tull Chapter, Daughters of the American Revolution, 1976.

Texas Education Agency. "Annual Report of County Superintendent of Public Instruction, 1884–1919." Archives and Information Services Division, Texas State Library and Archives Commission. Austin, TX.

Woodyard, Estelle. *Pioneers and Sundry Times*. Houston, TX: The House of Fine Printing, 1980.

DISCOVER THOUSANDS OF LOCAL HISTORY BOOKS
FEATURING MILLIONS OF VINTAGE IMAGES

Arcadia Publishing, the leading local history publisher in the United States, is committed to making history accessible and meaningful through publishing books that celebrate and preserve the heritage of America's people and places.

Find more books like this at
www.arcadiapublishing.com

Search for your hometown history, your old stomping grounds, and even your favorite sports team.

Consistent with our mission to preserve history on a local level, this book was printed in South Carolina on American-made paper and manufactured entirely in the United States. Products carrying the accredited Forest Stewardship Council (FSC) label are printed on 100 percent FSC-certified paper.

MADE IN THE

USA